ART

WITHOUT

COMPROMISE*

Wendy Richmond

ALLWORTH PRESS
NEW YORK

13 12 11 10 09 5 4 3 2 1

Published by Allworth Press
An imprint of Allworth Communications
10 East 23rd Street, New York, NY 10010

Cover and interior design by Wendy Richmond
Page composition/typography by Sharp Des!gns, Lansing, Michigan
ISBN: 978-1-58115-666-9

LIBRARY OF CONGRESS CATALOGING-IN-PUBLICATION DATA
Richmond, Wendy.
Art without compromise* / by Wendy Richmond.
p. cm.
Includes bibliographical references and index.
ISBN 978-1-58115-666-9
1. Art—Psychology. I. Title.
N71.R53 2009
701'.15—dc22
2009021993

Printed in the United States of America

For my mother and father, and for Max, Eli, and Owen

CONTENTS

Introduction

1 The Creative Process Loop

2 Culture's Frames and Filters

3
Life
Support

4
Questioning
the
Tools

5
The Medium Controls the Message

6
Another Kind of Language

7
The Twenty-first Century Landscape

8
Your Excitement Meter

Introduction

I am really smart for forty-five minutes each day. This occurs in the morning before 9:00 AM. I think my best thoughts, get my best ideas, and feel my most confident. My brain works at top speed; my thoughts are clear, deep, and far-reaching. This burst of creative energy fuels my work for the rest of the day.

But there are specific requirements. These forty-five minutes must be preceded by a short, brisk walk, where I am exposed to the outside world. The walk leads to a café, one that has enough people and diversity to provide a humming backdrop. Coffee, i.e., caffeine, is necessary (but not too much!). And I must have a sketchpad, a notebook, or a computer—something in which I can record my thoughts.

I jump from one idea to the next, one subject to another. I let the thought process flow, unedited. If I happen to glance out the window and notice a truck with a huge, colorful image on its side, I take the time to watch it pass by, and then I make a quick sketch to plant a seed for a future project. Or I eavesdrop on a too-loud cell phone conversation at the table next to mine, and remind myself of John Cage's philosophy: "Wherever we are, what we hear is mostly noise. When we ignore it, it disturbs us. When we listen to it, we find it fascinating." In other words, I trust that the culture surrounding me has a valid place in my creative process. Instead of considering these

digressions as interruptions to my work, I use them as essential ingredients. I know that they will, in one form or another, show up in my art.

There have been times when my forty-five minutes are neglected. Life gets in the way and must be attended to. Sometimes I just lose confidence and berate myself for being unproductive. But over the years, I have learned to say, "I need to protect this time and space. I must not give it away. This is what I need in order to make my best work."

<p style="text-align:center">*</p>

Non-artists look for the most direct and efficient route from point A to point B.

Artists seek the opposite. It is this circuitous path that offers up treasures, revealing the insights and passions that make your work meaningful.

When I say do not compromise about your art, I'm not referring to your final product. Instead, I am saying, do not compromise about what you need along the way. Not compromising means finding, committing to, and protecting your own unique requirements for making your strongest and most relevant art.

In *Art Without Compromise**, I ask you to look at what you see every day and place it in the context of your art making. My goal is to inspire you to reconsider the complex landscape that affects your creative process. The society that supports (and restrains) you, the media that informs (and misguides) you, the tools that aid (and confound) you, the culture that fascinates (and challenges) you—these are just a few of the subtle, often invisible factors that influence the art you create, and how your art is perceived.

My hope is that this book will change over time, just as you will. A chapter that you read today will mean something different when you read it in a month or a year. The order in which you read the chapters will change as well, depending on your interests at the time of reading. As the cultural critic and philosopher Roland Barthes believed, the meaning of a text does not come from its author; it comes from the reader. A text comes from a thousand sources of culture, and "there is a site where this multiplicity is collected, and the site is not the author, but the reader."

Most of all, I hope that this book will help you to immerse yourself in your own circuitous route, and to trust and protect what you need along the way.

1

THE CREATIVE PROCESS LOOP

You're in your studio and it's filled with all these people: friends, teachers, family, curators, art critics, and so on. One by one they leave, then you're alone. And then yes, finally, you leave, too.
—Philip Guston

Cultivating Creativity

Here's how I define a successful business meeting. All participants learn the goals that each wants to accomplish. We agree upon those goals, and we lay out a path to achieve them. I leave with clear expectations of steps and parameters including tasks, deadlines, budgets, and responsibilities.

Here's how I define a successful day in the studio. I arrive with some vague concept of what I want to create. I begin to work and find that the materials have a different plan for me, and I take my cues from them. Each step evolves from the previous one, and I am surprised as I work. By the time I leave, I have made something very different from what I had expected.

Cultivating a State of Not Knowing

I used to be uncomfortable with unknowns. But the more I allow uncertainty in my life, the more I am rewarded with unusual, and often positive, results. I'm basically trying to replace fear with curiosity, which then becomes excitement about learning something new.

I believe that I have an obligation to enter unknown territory. In some cases it's conceptual, and I experiment with, for example, a new form of photography. It's uncomfortable because it's usually unsuccessful 99 percent of the time, and out of all that work, I keep only 1 percent. But when I don't explore that territory at all, I have 0 percent.

Another aspect of not knowing is a technical one. It's scary to do work when you don't know the materials or the technology. For years, I held off buying a digital camera. I justified my hesitation by saying that the price was too high or the resolution too low, but the real reason was that I was afraid that there was too much to learn. I knew my film camera inside out and I was comfortable with it. But when I replaced the fear with curiosity, I began to think: What are the aspects that will allow me to grow? How will it change the way I take pictures? How will it change the way I see?

Removing Editors

In every project, whether it is personal or commercial, there are clients, bosses, curators, teachers, and colleagues, all of whom will tell you their opinions. We may be oppressed by them or uplifted by them, but there's little doubt that they affect us. And when we listen too much to them, we are not listening to the work itself. One of greatest (and most difficult to achieve) values in the process of art making is the dialogue that goes on within the work itself.

There are many examples of artists articulating their need to listen to what the work wants to do and how it wants to progress. It may sound trite, but remember the story of Michelangelo when he sculpted *The Dying Slave*? He was reacting to the block of marble and felt there was a form inside that he simply needed to free. Most fiction writers say that they don't determine what their characters will do; the characters tell the writer what they will do.

Finding the authenticity in your work involves getting rid of encrusted layers of opinions, styles, and accomplishments (yours and others'). And by the way, the most recalcitrant editor of all is probably you. During an interview for one of his exhibitions, the painter Philip Guston spoke, metaphorically, about what it's like in the studio: "You're in your studio and it's filled with all these people: friends, teachers, family, curators, art critics, and so on. One by one they leave, then you're alone. And then yes, finally, you leave, too." The point is that before you can hear the work, you have to silence all the people in your head telling you what the work means, encouraging you or discouraging you, and bringing their baggage. Even (or especially) you. The conversations, the influence, and the momentum are within the work: one step leads to another; one mark informs the next.

Quantity Equals Quality

In *Art & Fear: Observations on the Perils (and Rewards) of Artmaking*, David Bayles and Ted Orland describe a ceramics teacher who, at the beginning of the semester, split the class in two. One half was told they would be graded on the quantity of work: the more a student produced, the higher the grade. The second group would be graded on quality; to get an A, a student only needed to produce one pot, but it had to be perfect. It turned out that at the end of the semester, the work of highest quality was produced by the students in the "quantity" group. That group was constantly learning and improving, while the other group "sat theorizing about perfection" and did not progress in their actual work.

Most artists I know produce a huge volume of work in order to have just a few pieces to show. Each new piece contains information about the direction they should take. Producing a lot is a way of reaching a destination.

Reaching Your Goals

In school and in business, the physical goals for work are clear: the critique, the portfolio, the product on the shelf, the magazine ad, the annual report, and so on. But there is another way of thinking about the goals for your work, and that is to pay attention to the voyage (or process) of getting there. By trusting the state of not knowing, you keep yourself open. Your unformed ideas need time to meander. Keep working; the answers will come when they are ready.

The Creative Process Loop

I have a young friend, Ariel, who is a gifted photographer. Her images are unique, quirky, and fresh. One day while we were talking about her work, Ariel confessed her persistent fear: What do I do when the ideas don't come?

Anyone who has seriously pursued creative work has faced this problem. It is the visual equivalent of writer's block, and it's especially troublesome when the work is client-free, self-motivated, and personal. We often assume that we have to ride it out, like a physical disease, until that random lightning bolt miraculously returns.

But I believe that the problem is not a lack of inspiration. Instead, it is that the initial spark of an idea is so delicate that it is often prematurely stifled. It is subject to the terrible forces of nature: doubt, distractions, fear of the work being derivative, overwhelming technical complexity, lack of time, lack of discipline, and lack of money, to name a few. There is the desperate need to have the "answer" before one allows a simple germ of an idea to grow and morph, and to finally achieve its fullest realization.

This all comes down to two opposing fears. On one hand, you have the fear of the unknown: not having a clear idea of what the final product will be and wasting valuable time in a state that feels aimless and amorphous, without any sense of accomplishment or progress.

On the other hand, there is the opposite fear: that you will commit

too quickly to an initial idea and invest so much time and energy in that path that it becomes too precious. At that point you cannot abandon it, even if it is not what you want, and you continue, plagued with the pestering feeling that if you had stayed in a more exploratory stage early on, you would have found the right direction.

Is there a way to sustain one's creative confidence and energy throughout the entire process, from spark to product, keeping a balance between the unpredictable state of not knowing, and of tangible, visible progress?

One practice that I have developed to support the creative process—not only for my students and readers, but for myself, as well—is the Creative Process Loop, a disciplined approach to maintaining a balance between these contradictory poles.

The Creative Process Loop consists of three stages:

1. Observe. This is a natural act for any artist: watching, looking, and focusing on unnamed quirks of interest. Anything, from a stray hair on a sleeve to two people engaged in an explosive argument, can spark a nascent creative idea. The observation is accompanied by a method of recording, such as sketches of the strand of hair or notes of the couple's dialogue. These are not meant as final pieces, but simply as actions that set the scene firmly in your mind, as you might record a dream when you wake up.

2. Reflect. When you look at the sketches or notes you have made, which ones hold your attention? These pages are full of unformed, valuable nuggets that are often not evident until you look back on them. Reflection requires the discipline to review the notes and sketches and see what sticks. I have found that when I apply that discipline, it provides the space to daydream, and furthers an idea in a non-pressured way.

3. Articulate. In the first two stages of the Loop, the work is for your eyes only. The thoughts and ideas are not spelled out and are not in any cohesive, comprehensible order. They make sense only to you. Articulation is the hardest stage, the one that requires the greatest discipline: stating these ideas clearly, translating them into a tangible form that can be communicated to others. It's also the stage that reaps the greatest rewards. When you articulate, i.e., create a physical piece that can be presented to others,

you achieve a sense of accomplishment and visible progress. But, because you know that it is merely a small piece in an iterative process, you don't have to be so invested; it is a step along the way. When you present this tangible piece, you begin the cycle again: observing the reaction, reflecting on the feedback you receive, and creating another iteration—in other words, engaging in the Creative Process Loop.

The most important part of repeating this process is to maintain the balance between not knowing and having the "answer." Imperative to the success of the Loop is that you move quickly through the stages, resulting in a form of rapid prototyping that removes the preciousness of investment. With each cycle, you move closer to your goal.

Setting
Up
and
Letting
Go

After making a particularly difficult presentation at a huge conference, I had a revelation. I had been so focused on rehearsing my scripted words that I'd neglected what was going on around me: the other speakers, the audience, the conference itself. Determined to be prepared, I had complete control of the words I would say, but at a cost. I missed out on ideas from the other presenters that I could have used to make my own points more relevant. And even though I was aware of the audience, I did not incorporate their reactions; instead, I stuck to my prepared text.

This made me think of an outdoor concert that was the opposite of my own experience. During a solo piano performance, a small airplane flew overhead, and it was just loud enough to be distracting. The pianist began to improvise, using the engine's hum as though it was music from another instrument. The airplane became his partner in an exquisite duet.

My revelation, in short, was this: relinquish the control that you never had in the first place.

Of course, it's important to be prepared and to do the hard work that will ensure the best results. But part of that work is acknowledging and accepting the role of chance, and even building it into the plan. Whether it's a performance, a client meeting, or a photo shoot, if you consciously make room for serendipity, there's more of an opportunity to take advantage of it.

Collect your experiences, tools, resources, and confidence so that you have a strong foundation. Then, let go.

I often look to contemporary art for useful metaphors. When I spoke to the sculptor Chris Abrams about his *Postal Drawings*, he helped me to clarify and articulate this notion of setting up and letting go.

Chris described the drawings as "documents of a series of events that took place entirely through the mail." In one example, a small cardboard box was lined with white paper, and a "ball stylus" (a sphere with approximately ten pencil points protruding from its surface) was placed inside. In another, the form was reversed: the paper was affixed to a cylinder, which was then inserted into a tube that was lined with pencil points. The work is both conceptual and physical; the process is a crucial element of the product.

The entire drawing is created in the mail by the chaotic action of the pencil points and paper inside the sealed box. It's an experiment with randomness and chance in a controlled environment. The drawing is completed when the package arrives and the box is opened. The recipient is the first to view the completed piece.

The pieces are a way of relinquishing the traditional control of the artist over the work; they are about setting up a fixed set of conditions and letting the work create itself. I have retracted myself from the process to the point where I don't even see the finished product. The viewer becomes the sole perceiver of the work, if he so chooses. However, it's not a complete negation of the author [or] artist, because as random as the process is, it still occurs within fairly narrow confines that I've set, and in that respect it is somewhat predictable. It's a compromise between total control and self-negation. The process sits between managing all the details and parts of the piece and an abandonment to forces beyond our control. Artists have been playing with this idea for years.

Like the delicate, frenetic drawings they produce, Chris's boxes and drawing implements are beautiful pieces. I imagined these creatures bouncing their way through the postal system, and as I pictured each stage of the journey, they accrued more and more meaning. Mailboxes, postal workers, and post offices have all sorts of connotations, and it's impossible to view the work without making those connections.

You make careful plans and then, because of events, timing, or any

number of factors, the work undergoes some transformation. Chris's work is an example of a simple truth: your work never exists in a vacuum. The idea that you can exercise complete control is not only delusional, it is counter-productive. Powerful work is often defined by its ability to remain relevant within a new set of circumstances that occur after the piece is conceived. Our creative efforts will find their way to places, audiences, and interactions that we could never predict. We have a lot to gain when we allow the work to be nourished by whatever surrounds it.

Bringing
Play
to
Work

Back in 1994, the innovative advertising agency Chiat\Day redesigned its headquarters in New York. In an article in the *New York Times Magazine*, Herbert Muschamp described the new office as the "architectural equivalent of a brainstorm: 29,000 boisterous, loosely organized square feet, bursting with color, form, and wit."

This *joie de vivre* approach made quite an impression on me and prompted me to give this assignment to my graphic design class: create a design studio that embodies the essence of enjoyment and creativity. I asked the students to start with a space that would be totally absurd as an office. The goal was to discover what made certain environments enjoyable and to see how that could be integrated into the working process.

It didn't take the students long to come up with a proposal. They would design their studio in an ice skating rink.

They described the essence of the rink and its appeal as a creative space: The cold air energizes you as soon as you walk in; the vast, fresh surface is like a huge canvas; and the human forms are kinetic sculptures whose body movements evoke emotion and communication.

The students' design employed aspects of a rink: a catwalk on the second floor housed the working studios, where everyone had a view of the space; a scoreboard was the central communication and display device, with changing content (it might display skaters, a video clip, or internal

announcements); the penalty box held bad designs and particularly egregious typos. Their list went on, incorporating music, buzzers, projections on the ice, and, of course, the Zamboni, which cleared the ice like a giant chalkboard, ready for fresh ideas.

The students proved the validity of a studio within a rink by showing the brainstorming process leading up to a finished project. They projected slides they had taken of the ice after they had been skating: big, flowing, freeform shapes. Then they showed their finished poster: an announcement of new typefaces. The poster displayed the letterforms in a grand, loose, anti-grid fashion. The shapes on the ice were very much like the typographic forms on the poster.

Next, the group deconstructed an existing TV cookie advertisement that used a theme of animated chocolate chips. First, the students showed a video of skaters with electronic sensors attached to their joints. This, they explained, was how their studio would create realistic animations: as the skaters skated, the designers could record their movements. Then they showed the actual TV spot. The chocolate chips did, indeed, look like skaters zooming around a rink. As the students presented each new element, their energy doubled. They were clearly having fun.

Years ago, I worked in a small startup company. We rented an apartment for our office, and the owners cleared out all of the furniture except for a pool table. As our company grew, we needed to make better use of the space. I suggested we lose the pool table. Fortunately, my stupid idea was immediately vetoed. The pool table was our most vital piece of equipment. It was the spot where we brainstormed, relaxed, solved problems, and made jokes. The combination of work and play was seamless.

As I watched my students continue on the design of their studio, I was pleased to see their willingness to embrace eccentricity and to find new and unconventional paths. What I had not expected was that they would also identify a creative essential that we often forget, even eliminate, in our work: the element of play.

Visual
Reflection
Notebooks

One of the most difficult and elusive phrases for an artist to complete is: "My work is about . . ." Making art is personal and intuitive, and often we don't know our intention until after (sometimes long after) the work has been completed. It's common for artists to question their direction and struggle with defining what their work is "about."

If you're like most visual artists, you have piles of work stored away; some pieces are recent, and some you haven't seen for years. You also have folders of postcards, quotes, article clippings, and reproductions of other artists' imagery, all of which have inspired you and contributed to your own development. And you have boxes of sketches and notes about ideas that may or may not have come to fruition.

These items are invaluable. They contain vital clues about the evolution of your work and can help to accelerate and strengthen your growth, especially if you bring them together in ways that reveal underlying themes and patterns. The key is to see both the detailed and broad expanse of your output and influences from a period of years, and to see it all in one place. Think *Powers of Ten* (the classic film by Charles and Ray Eames), but with the added dimension of time.

Several years ago, I developed a technique for translating past work and influences into a form that can, as an entity in itself, shed light on this continuum. I call it the visual reflection notebook.

My goal was to locate the common threads in my work for the past decade. Part of my difficulty was that the work encompasses many different forms: graphic design, sculpture, installation, dance, photography, and writing. I took a big chunk of disparate elements (ranging from slides of old installations to new photographs to clippings from magazines) from my stockpile and reduced each item to a common denominator by making small, black-and-white photocopies. Using a glue stick, I pasted these into a blank, 4" × 6", hardbound, 110-page sketchbook—the kind you get at any art store. The sequencing was purposely random, as though I had shuffled a deck of cards.

The result was a single object that allowed me to view, in my hands at one time, years of my process and production. It also contained surprises: juxtapositions that revealed similarities in old and new work, influences of artists that I had forgotten, a quote that had new meaning when paired with a new image, and so on. Unfinished work predicted the beginning of new work that has been completed, exhibited, and sold. This tiny notebook emphasized patterns and themes that, without these serendipitous comparisons, I might never have seen.

To date, I have made almost a dozen notebooks. Some of the images repeat in different notebooks, and the sequencing always changes. Items gain meaning based on their juxtapositions, and rearrangements instigate new conversations between one body of work and another. I leave occasional pages blank so that I can write comments. When I review a notebook, I often find new insights, which I add to the already dense comment pages. Each notebook continues to evolve.

I also use my visual reflection notebooks as a sort of "workbook" in my classes and workshops. Many of my students are artists with years of work behind them, and they want to define their direction more clearly and uncover their own unique "handwriting." The exercises for making notebooks always elicit discoveries. Some students have pursued new avenues, while others have renewed their commitments to themes that had been forgotten or overlooked.

There are many ways to arrange the contents of the notebooks and to use them by yourself or show to colleagues for their input and critique. Here are some recipes that may help you to start your own.

Serendipitous Juxtapositions

As I discovered while making my first notebook, random juxtaposition can help uncover unexpected similarities. For example, a double-page spread happened to contain one image from 1997 and one from 2008. My earlier work focused on inanimate objects; the later work included people. In each case, the major elements were characters. The juxtaposition made me see the ways in which the objects and the people were interchangeable players in a drama.

I also realized that I'm most comfortable working in series, using a central element that changes over time, often through hundreds of images. Now, feeling encouraged by this consistent and enjoyable pattern in my process, I can concentrate on developing the narrative.

Chronological Order

In addition to random placement, there is great value in chronological sequencing. It shows your development and choices over time and reminds you of directions that you may have mistakenly dropped.

One of my concerns about art education is that we tend to critique our individual pieces rather than bodies of work. While you may study the long history of art and how one era influenced another, your investigation of your own work typically covers a very short span of time, whether you have been making art for a few decades or just a few years.

A key component in identifying themes and patterns is to look at the continuum of your work over time. Which paths did you pursue? Which did you abandon?

Didactic Failures

This leads to my belief in praising failure. We all know how important mistakes are to the creative process. The late Agnes Martin said: "The bad paintings have to be painted, and to the artists are more valuable than those paintings later brought before the public." The work that you rejected was essential as a way to get to where you needed to go. It was part of your dialogue with the work; the necessary process. One student told me that she was interested in my notebooks because they showed the paths I decided *not* to take.

I encourage students to include failed work for two primary reasons. First, there was an impetus in that work that may have been discarded

prematurely, before it had a chance to develop. Second, in identifying failure, the direction that you *did* choose becomes clearer.

This Is Not Precious

Another important factor is reducing preciousness. By giving all images the same characteristics, you can make comparisons without getting distracted by questions of technique, surface texture, print quality, etc. You are equalizing the work as much as possible. And because the notebooks are made of photocopies and printouts, you can draw over the work, write on it, rip it, and crumple it. Images are easy to multiply, so you can repeat and change pairings or sequences. I often work on my notebooks on airplane trips. I try to bring at least two copies of each item or image so that I will not hold back on messing up.

Other Influences

I recommend including work of artists you admire and seeing how they have influenced you, knowingly or unknowingly, overtly or obliquely, literally or philosophically. Even though my medium is primarily photography, I have also included images and writings of painters, sculptors, architects, and writers, including Philip Guston, Rachel Whiteread, Richard Serra, Ann Hamilton, Renzo Piano, and Kenneth Koch, to name just a few. By including references to others' philosophies, work ethics, humor, and sensibilities, all in the same little container as my own images and writings, I see my own direction more clearly.

Placing your work next to an artist you admire comes with a warning: thicken your skin. I included a photograph by Francesca Woodman in one notebook and saw the similarities in tone, composition, and mood. But as I flipped through the notebook later and came upon her image, I thought, "Damn, her work is so much stronger and more arresting than mine." After the initial blow, I tried to understand why hers was more powerful. When I realized that its beauty was in its interplay of simplicity and complexity, I began to look more carefully at those aspects in the form and content of my own work.

How Others See It

Creating these notebooks is not always a solitary endeavor. In one class exercise, students divide into groups of three; two students "arrange"

approximately forty images belonging to the third student. (The third student is instructed to stay silent.) The team of two looks for patterns, sequences, and affinities among the images. The student who watches his work being arranged gets the gift of a new perspective.

When you silently watch your work being handled, so to speak, by others, you witness an audience's interpretation. They make patterns that you may not have intended. This usually encourages a fruitful discussion that can lead to more insightful questions. Do you consider your work abstract, while others see a narrative? Or if you do have a story, is it obvious or obscure?

The pages of these notebooks are juxtapositions of time, media, failure, success, opinion, and inspiration, all reduced to the common denominator of black-and-white, 4" × 6" photocopies. The notebook is not a retrospective, nor is it a diary or journal. Though it has those elements, its purpose is not to show your best work, nor is it to record your life. Instead, its aim is to discover underlying themes, directions, and patterns that you may be missing and that can inform your current and future work.

A visual reflection notebook is a place where the many pieces of your work and others' can have exciting conversations. It's up to you to populate the party and provide a really good group of attendees: past and current work, other artists, insightful writings, etc. The conversations are ongoing; keep adding, keep reflecting. The more you make, the more you learn what your work is, after all, about.

Developing a Creative Practice

When I go to a yoga class, I expect to be told what to do. But the new yoga place I recently attended was clearly different. First of all, I couldn't figure out who the teacher was. Second, no one was doing the same thing; any unison of movement was coincidental. I looked for someone—anyone!—to follow. After a while, one of the people (who, it turns out, was the "teacher") came over to me and said, "It's best if you develop your own practice. That way you won't have to depend on someone else to lead you, and you'll be able to discover what *you* need."

I soon discovered that this was not an exercise class. The weekly meeting is one of the ways that each member bolsters the commitment to his or her own progress. It's a time and place where people come together to support a self-directed and self-motivated practice.

The more I thought about it, the more I realized that this was a good analogy for artists. What does it mean to have your own creative practice?

Anyone who has pursued creative freedom knows that it's a double-edged sword. Personal work is an opportunity to fully explore your own vision and passion, to follow paths further. You make your own timeline, set your own goals, and follow your own passions. How inspiring! Then again, how intimidating!

We are accustomed to relying on businesses and schools to provide the structure for creative output: a client or teacher to please, a deadline

for adrenaline, a paycheck or a good grade for acknowledgment and kudos. Outside of those structures, it's difficult to find and sustain personal motivation. So, how do you maintain your allegiance to doing your own creative work when the support structures that you have relied upon disappear?

Many of us are familiar with school as a foundation that supports the creativity of its participants. Taking pieces of this structure may help you to construct and maintain your own creative practice. In my work as an educator, I have focused on developing a pedagogy that supports creativity. Below are some of the practices that I encourage my students to adopt for the long run.

Working Side By Side

In most of my classes, I ask the students to work in small groups. I'm always impressed at their process. Students share ideas and skills and they hang out together. Working side by side, whether on joint projects or separate ones, is their way of supporting each other's creative process. Just knowing that you are in proximity to someone else who is engaged in similar creative struggles is motivating.

In her doctoral dissertation at Harvard University, "Passionate Curiosity: A study of research process experience in doctoral researchers," Joy Amulya studies the similarities between the work of research and that of other creative disciplines. She describes many of the struggles and activities that help people progress and achieve insight as they work.

In particular, Amulya notes the common challenges in creative work, like isolation and the need for supportive relationships. In one example, she described a "parallel creative process." Jesse, a woman working on her dissertation, was often visited by a friend who would play the piano while Jesse was typing. Jesse was energized by this kind of "parallel play" of their keyboard duet.

Required Studio Time and Place

Not having a regular schedule and place to show up can be freeing, but it can also be a burden. Distractions are much more likely to step in the way and prevent you from getting to work. When you are working on your own project, it's a good idea to impose a timetable and location and commit to it.

Natalie Goldberg, author of *Writing Down the Bones*, describes a period in her work where she and her friend Kate met every Monday morning

at nine and wrote until about two in the afternoon. Then, they read aloud to each other what they had written. Making a commitment to show up and work is simple but powerful, whether that commitment is to a partner or to yourself.

Critiques and Feedback

Critiques are an essential part of class time, and my students come to depend on them as motivators for their own progress. In one course, students met weekly in "triads." The triads were mini critiques, meant to sustain and further the work. The agenda of the triad was always determined by its members: it may have involved dinner, sharing technical skills, airing frustrations—whatever they needed. You may say this is stretching the definition of the critique; I say, let's stretch it further. This is a way to acknowledge and then maintain the supportive structure that is typically lost after graduation.

I tend to get bogged down when I am working alone on a project for long periods without any feedback. Sometimes I need an opinion or a new perspective, and sometimes I just need to know that I have an audience for stages of work. During those periods, I e-mail new images to my best friend who is a writer. She, in turn, sends me pieces of whatever writing she's currently working on. Our comments to each other are brief, but they acknowledge the progress in our respective work.

Insights From a Daily Practice

I often ask my students to keep a daily journal for their own private use. Each student selects a medium in which to record thoughts and processes. Depending on their choice of medium, they think of it as a sketchbook, a scrapbook, a "thought-stream" recorder, etc. The point of a journal is not to make a product; instead, it is a way to become familiar with your own process of discovery. It is key to make this a daily routine. Through this repetition, you find out what you are most interested in and most passionate about, and through that articulation, you grow. As Susan Sontag wrote in a notebook entry from December 1957, in *Reborn: Journals and Notebooks, 1947–1963*: "On Keeping a Journal. Superficial to understand the journal as just a receptacle for one's private, secret thoughts—like a confidante who is deaf, dumb, and illiterate. In the journal I do not just express myself more openly than I could to any person; I create myself."

Finding a Non-Precious Routine

A huge struggle in any creative work, whether you're working alone, in school, or in business, is the pressure of coming up with something new, insightful, original, and unusual. At the very least, every project comes with this nagging question: Am I doing something worthwhile? When you're working on your own project, it's even more difficult. You're not solving a problem that has been assigned by someone else, and therefore you have to take responsibility for the initial idea *and* the outcome.

I found similar concerns in Amulya's dissertation. She explores reflective practices in research, and describes thinking about her work ". . . in terms of some kind of regular, non-threatening routines that would help me learn to engage with (my work) as a process, rather than a performance. . . . I longed for the research equivalent of practicing scales, methodical ways that I could be in an ongoing, active relationship with my research work-something different from trying to formulate big thoughts or ponder deep issues . . ."

Committing to Creativity

By choice or not, there will be times when the source of motivation to do creative work must come from you. A creative practice is an independent set of habits and procedures. The projects are self-motivated, self-judged, self-generated, and self-rewarded. It's a commitment to a routine that leads to revelations. It's a way to find the authenticity in your work. Your commitment provides nourishment for you, and, whether you know it or not, for others.

The Underlying Questions

There is a stage during an artist's development of a body of work that often gets neglected. It is the stage between finishing the artwork in the studio and bringing it out to the public.

You're probably thinking that I am going to talk about marketing and promoting your art. I'm not. Way before you revamp your Web site or schedule a studio visit, you must have a clear understanding of what your work is "about." You need to be able to articulate its themes, how it developed, and where it is going.

Whether your goal is to publish a book, secure representation at a gallery, or win a grant, there are the expected topics you will be asked to address, ranging from describing the intention of your work to identifying its potential audience. But behind each of these tasks, there is an underlying, less obvious, sometimes invisible question that you need to answer first, for yourself.

When I speak with my colleagues and students about this step between completing one's work and presenting it to the public, these "pairs"—the expected task and its underlying counterpart—seem to resonate, illuminating areas for deeper consideration.

Expected task: Describe the evolution of your work.

Underlying question: Do you know what the consistent themes of your work have been, and can you point to where your work is going?

We tend to look only at our current projects; the older work is, well, old, and we are more interested in what we're doing now. But the past work holds important clues. After years of concentrating primarily on still and moving images, I am currently developing a project that is solely typographic and haiku-like. I recently unearthed an art school project from the time when I first fell in love with typography's ability to subtly and concisely express a feeling. I see that in my present undertaking, not only am I bringing back an earlier thread, but my use of typography is consistent with my use of imagery; both are concise and visually minimal.

Expected task: Participate in a live interview about your work.
Underlying question: Is your work developed enough that you can speak comfortably about it?

I often begin a class by having students interview one another as if they are showing their portfolios to a gallery owner, publisher, grant giver, etc. This forces students to identify areas they have not explored. For example, one photographer was having trouble describing her work in a cohesive way, and as a result, was contradicting herself and feeling increasingly awkward. After reflection, she realized that she actually had two separate and distinct bodies of work, and she felt more confident as she clarified their differences.

Expected task: Describe the relevance of your work in today's culture.
Underlying question: Do you believe that your work is relevant to present-day topics? And do you care?

I do, so I ask myself if my work addresses contemporary issues. I tend to use current tools and media, and I sometimes fool myself into thinking that this makes it relevant, when in fact I am sidestepping the more important aspect: content.

Expected task: Explain why you are applying to, requesting money from, or want to show at this particular venue.
Underlying question: What is the proper outlet or venue for your work?

The typical advice for artists is to research galleries and approach the ones that are compatible with your genre. But what if galleries are the wrong venue for your work? I often confound my students by asking them

the question that lays yet another layer down: you are thinking about where *you* want your work to be, but where does your *work* want to be? Of course you want a show in a well-known gallery or museum, but is your ego speaking more loudly than the needs of your work? Your particular art may be better served in a book that can be held in one's hands, or interacting with the debris of a vacant storefront, or on the stage of an experimental theater. Does your work want to be perishable or precious? Exclusive or widely accessible? Intimate or public?

Expected task: Describe your project in 200 words or less.
Underlying question: What is your work about?

This is the mother of all questions, and the most difficult one to answer. Being able to articulate the intention of your artwork is a sort of Holy Grail. No matter how many exercises you engage in, the process of asking and answering this question will (and should) repeat in an endless and self-revelatory loop.

2

CULTURE'S FRAMES AND FILTERS

You do *have a cultural identity, and it is an amalgamation of cultures. Culture is like chocolate at 98 degrees. It's sticky and you can't help getting it on you.*
—Arthur Ollman

Seeing Your Work in a Historical Context

When I was in graduate school, I was presented with a question that was perplexing, revealing, and caused me to fill several notebooks with early morning writings. The question, which is as powerful as ever, was this: How do you describe your work in a historical context?

I believe that we spend too little time asking questions about our own work, and therefore, we don't understand it as deeply as we could. Most of the essays I write, most of the courses I teach, and for that matter, most of those notebooks I fill are in an attempt to expand that understanding. When I began to actually tackle this question about historical context, I realized it was a good way to structure a didactic activity, a step-by-step exercise to think more deeply about one's work.

Separate the question (How do you describe your work in a historical context?) into three concentric circles, from personal to general. First, describe the history of your own work; second, describe the events and circumstances during the time you were (and are) working; and third, identify the influential events in the history of your artistic field.

The History of Your Work

Begin by reviewing the work you've done over the years of your career in the visual arts. Include student work, because that often reveals the greatest insight, and it may be where you first discovered your passion. (If

you can actually look at some of the work, so much the better.) What were the projects that were important to you? What tools did you use? What was the subject matter? What was the medium? Where were your ambitions? What was the most satisfying aspect, and what was the most frustrating? Take note of themes and characteristics.

After much thought, I realized that my favorite projects involved innovation, new tools, and hands-on processes. When those elements were missing, I knew that I needed to make a change.

Contemporary Events and Circumstances

Next, consider the events and circumstances surrounding you at the time of each of these projects. What was going on socially and politically while you were doing this work? The Civil Rights Movement? The Vietnam War? The Internet boom of the 1990s? The aftermath of 9/11?

My first career (graphic design) began at a powerful moment in the feminist movement. My choices were influenced by my desire to be successful in areas that were dominated by men, such as new technology. Some of my friends from art school were designers before they knew what graphic design was, having created anti-war posters, banners, and pamphlets.

The History of Visual Arts

This topic seems absurdly huge, but first, take note of your approach to addressing it. That, in itself, will be revealing. Do you look at history through the lens of religion, politics, commerce, ecology, race, or media? Does your work have more resonance with one than another?

I tend to think in terms of media, and I am amazed by the number of tools and processes that artists have chosen to combine, mixing old technology with new. Limited edition books are reproduced (beautifully) as laser copies, animation combines drawing and interpolation, letterpress and ink jet share a sheet of handmade paper, a camera obscura image is refined on a laptop computer, and so on.

So, I ask the question again. How do you describe your work in a historical context? When you look at your projects on a historical timeline, you can begin to see how the events and circumstances have affected and continue to affect your work-and, perhaps just as importantly, how they affect your audience.

Frames
and
Filters

We know the world through frames and filters. Some filters are tangible, like television, the Internet, newspapers, and magazines. Some are ephemeral, like current styles and trends. And some are deeply entrenched, like the environments in which we were raised, or the cultures that embrace or reject each of us.

Our thinking, our goals, and our beliefs are based on these filters, these ways of knowing. And yet the filters are transparent, sometimes invisible. We are often oblivious to their origins and to the reasons that they exercise such power over our lives. We are governed by the versions of reality that they present: fabrications that we accept without a second—or first—thought.

Every year we see reviews of "the best." The best movies, the best books, the best inventions. What constitutes "best"? Are we aware that our definition of excellence is based on a construction of historical and contemporary influences in philosophy, art, politics, and business? We say, for example, that the design of a new building is good because it is simple, innovative, conceptual, efficient, accessible, and green. Every one of those adjectives is an accolade because somewhere in history, recently or long ago, that characteristic became a filter, and that filter was labeled "good."

The above paragraphs may sound like a gloomy assessment: we live in and are controlled by an unsteady cultural environment. However,

if we look more closely, we can see that this complex set of filters provides the greatest atmosphere for creativity. By exploring and digging deeper, we bring more meaning to what we see and what we make. We may find that our goals and ideals are based not on fads but on more substantial factors that have a history and a lineage.

It's exciting to observe evidence of backgrounds and foundations. Consider again the qualifications of a good design. Something as innocent as the word "simple" is an attribute that, at some point in time, became positive. One influence that comes to mind is the popularity of Shaker furniture and utensil design, particularly in the fertile grounds of modernism, where purity of form and material rule. Many contemporary designers have been inspired by the clarity of Shaker workmanship and functionality.

And work that is praised because it is "conceptual" owes much of its thanks to the founding father of conceptualism, Marcel Duchamp. In his work, the idea was more important than the object. A lot of contemporary advertising, in which you don't actually see the product at all, can trace its lineage to Duchamp.

Efficiency is an attribute that may have some foundation in the Industrial Revolution, when large-scale mass production and fast-moving assembly lines were the success stories.

These filters of media, history, and culture are always changing. Their influence grows and shrinks depending on time, place, and the person who is looking through them. That's where our own creative freedom lives. Each of us, as individuals, absorbs these filters, and with them we bring our own meaning to a piece of work.

One summer I attended a course called "The Literature of Art." The readings included an essay by Roland Barthes titled "Death of the Author," from *The Rustle of Language*. Barthes's premise is that the meaning of a work does not come from its author; it comes from the reader. A "text," whether it is literature, dance, or music, takes on its meaning at the time that it is read, seen, or heard. Until the act of viewing or listening, the meaning lies dormant. It is at the time of the action that the meaning is applied.

Saul Ostrow, the professor of the class, explained Barthes further by saying that the job of the reader is not to seek the author's meaning but to seek her own meaning, bringing all she knows to bear on it. The author gives the reader a script to follow, but he wants it interactive, not nailed down.

This reminded me of a discussion at a conference years ago. Designer

Ralph Coburn commented on the note-taking he had observed over peoples' shoulders. He said that the boring notes were the ones that were taken verbatim; transcriptions of exactly what the speaker had said. The interesting note-takers, on the other hand, were those who went off on tangents, using the speakers' intentions as a point of departure, and then applying their own meanings to reach a new, individual destination.

For me, one of the best things about frames and filters is that they accumulate and we each get our own unique, giant plateful. As Barthes says, a text comes from a thousand sources of culture, and ". . . there is a site where this multiplicity is collected, and the site is not the author, but the reader."

Ways
of
Knowing

I gave my goddaughter Sofie a tool set for her Bat Mitzvah. There's an assortment of screwdrivers, a socket wrench, pliers, wire cutters, and so on. In a letter explaining this odd gift, I told her that it was part practical, part symbolic. On the practical side, I wanted to encourage the delight of making things. When you have good tools and know how to use them, you get the wonderful experience of amplifying your ability to create. On the symbolic side, the tools represent the confidence that comes from knowing basic principles. This gives you a foundation or procedure to learn what you don't already know.

As I chose the tools, I realized how much I miss the boyhood I never had. When I was in grade school, it was typical for girls to learn "home economics," i.e., cooking and sewing, while the boys were in shop. I never took physics in high school or college. It seemed that a hands-on knowledge of how the physical world works—basic stuff like motors, electricity, gravitational pull—was not a necessity, and I remained mostly ignorant of such things.

A few years ago, my work migrated from 2-D to 3-D, and a lot of the latter was heavy and large. In order to work alone in my studio, I began to learn about tools and methods that would help me balance, move, hoist, hang, and construct. But I was frustrated by the fact that the knowledge was not in my bones, as it clearly was with my male friends who learned about physics

at an early age. In general, it seemed that having a lifelong relationship with the subject had given them much more than a bunch of facts; they also had an intuitive methodology for finding the answers to whatever they didn't know. When I watched their process of helping me to install, say, a pulley system, I saw a path—an uninterrupted flow that moved from curiosity to observation, hypothesis to proof. This practice is not just for figuring out how things are constructed. It is an approach to life, a basic way of viewing the world. As Judah Schwartz, a well known author and professor of mathematics and science at Harvard and MIT, told me, "It's a way of knowing."

I was fortunate to teach in the same department at Harvard as Professor Schwartz, and in meetings I often admired the way he worked through issues. I decided to ask him to talk more about this "way of knowing." He said, "It's about having the arrogance and the willingness to make outrageously simplifying assumptions." He explained this approach with a story about Enrico Fermi, the great twentieth-century physicist. Fermi used to ask his students, "How many piano tuners do you think there are in Chicago?" He then followed the question with a path of assumptions. Let's say there are eight million people in Chicago, and let's say there are four people in a family, and of those two million families, let's say 10 percent have pianos. He went on until he reached a conclusion of how many people could earn a decent income tuning a given number of pianos. Step by step, he made assumptions in order to move towards an answer.

Professor Schwartz told this story to illustrate that you must be willing to ignore a lot in order to figure something out. By making a simple model, you reduce a complex problem into simple parts. Later, I was inspired and started to write the story on paper, but I had forgotten the numbers. My immediate reaction was: "I need to look up the population of Chicago." Then I thought: "Actually, this was many years ago, when the population was smaller." I had interrupted my progress before I even began. I felt discouraged before I had even gotten to the good stuff. The point is to be able to make an appropriate model—a rough outline that lets you progress logically. I'm envious of people who are so well versed in this approach that it's instinctual.

I'm not saying that I would trade my own way of knowing. In much of my work, it's imperative that my process not be linear and that I do not build a model from which to proceed. But I don't want to limit myself to one way of working, and the more ways of knowing I have, the better.

I plan to add to Sofie's tool set on her next birthday, and maybe I can get some two-for-one deals. I'm looking forward to giving her the boyhood I never had.

Pilgrimage

While waiting for the train from Boston to New York, I happened to see an announcement for an environmental sculpture exhibit in a small town about thirty minutes west of Boston. I had seen photographs of the work of one of the artists, Bill Botzow, and I wanted to experience his sculpture in person. The show had a long schedule: autumn and early winter. It was months before I found the time to go and a car to borrow. I hate to drive, and naturally, I got lost. I finally found the location, but there were no directions to the actual piece. I only had its title: "Wedge." By luck, I headed in the right direction, and suddenly, there it was, stuck firmly between the rocks. It was impossible to miss because it stood out so clearly, yet it was absolutely in the family of its surroundings. I stayed with the piece for a while, feeling a great mixture of pride and a personal connection to the work.

Later that year, I was reminded of my visit to Botzow's sculpture when I read Michael Kimmelman's *New York Times* article, "No Substitute for the Real Thing." Kimmelman's article was about making a "pilgrimage" to see a work of art. His subject was the Grünewald Isenheim altarpiece in the Unterlinden Museum in Colmar, France. Those who make a special trip to this town are, in all likelihood, going specifically to see this particular work of art. Kimmelman discussed the idea that as more art comes to us (for example, in large, "blockbuster" traveling exhibits), we miss the powerful experience that results from going out of our way to see a single, specific work.

This made me think about the ways I receive my intellectual and cultural nourishment. Besides individual people, most of it comes to me through some distribution system. Books, magazines, television, movies, Internet, radio, and newspapers are all delivered to me either at my home or studio, or are available within a few blocks. The content is mass-produced, or at least made in such a way that it will achieve maximum distribution. I also get my nourishment from events and exhibitions: lectures, art exhibits, concerts, theater, and other performances. Typically, they are events that have been publicized and reviewed, which guarantees a level of acceptance.

So, for the most part, I don't go out of my way to get this content; it comes to me. The sources of my cultural and intellectual information are part of a system of mass production. Even if the subject is unique, i.e., an original, it is still part of a "delivery" system that ensures that many people will see it.

Please don't get me wrong. I am deeply grateful for these resources. Without them, I would suffer from cultural malnutrition, and this would be, for me, an unhappy life. What bothers me are the times when the content is geared to the lowest common denominator in order to guarantee that the greatest number of people will listen, read, attend, and buy. That approach is at the expense of risk, originality, and complexity.

When I choose to go out of my way, I create a stronger connection to whatever I went out of my way for. The more effort I put in, the more invested I am in getting something back. As I think back to Botzow's sculpture in the woods, I realize that, like the lectures, magazines, exhibits, and performances whose goals do not include a high volume of distribution or attendance, it provided the missing nutrients for a healthy cultural diet.

Identity
and
Authenticity

When I went to Tijuana for the first time a few years ago, I felt a rush of visual adrenaline. As we drove through the city, I saw stores, houses, signs, and cars that were unique assemblies of resurrected materials. It looked like personal histories on display.

Soon after my trip, I went to an exhibit titled "Informal Economy Vendors," featuring the work of Julio César Morales, an artist from Tijuana (now living in San Francisco). His work documents, through various media, Tijuana street vendors' customization of their pushcarts. The wall text said, "Each unit is unique because there are no prefabricated models. Vegetable, fruit, and burrito carts are constructed from items like an American golf cart, a velvet seat, or a gleaming metal steering wheel . . . a hybrid mix of recycled materials."

After these experiences, I thought about how much I enjoyed the vibrancy of this kind of assemblage, and wanted to incorporate it into my own visual work. I wanted to spend more time in Mexico. But along with this inspiration, I had a simultaneous feeling of separation; this is not my culture, so I can only be an observer, not a participant. Morales grew up in Tijuana, and his grandfather is a pushcart vendor. His constructions are part of his heritage, his cultural identity, and therefore, he has a right to excavate this visual sourcebook.

I have often imposed a restriction on myself: if I was not born into a

culture, then I do not have permission to practice it. In my overly eager political correctness, I was afraid that any adoption—or adaptation—of someone else's culture would be appropriation, or at the very least, fake. Worse yet, I did not consider myself to have a distinct cultural identity of my own.

One of the (many) definitions of "cultural identity" is how one identifies oneself in terms of belonging to a group, whether that group is based on race, ethnicity, sexuality, religion, education, lifestyle, and so on. People in the arts are particularly sensitive to cultural identity; in order to create something meaningful that truly communicates, the work must be authentic, and authenticity requires firsthand knowledge.

How, then, could I make powerful work if I did not belong to a specific culture?

I mentioned this growing uneasiness to a wise friend who thinks deeply about issues of art and culture. He gave me an alternative and more open perspective. He said, "You *do* have a cultural identity, and it is an amalgamation of cultures. Culture is like chocolate at 98 degrees. It's sticky and you can't help getting it on you."

He went on to say that Americans are exposed to many cultures, and we absorb everything from mannerisms and gestures to ideas and beliefs. All of us, as individuals, pick up nuances that, without our even realizing it, become part of who we are.

This made me think more about Morales's work in the exhibit. While it referred to recycled, handcrafted pushcarts, the majority of his work was technology-based. His two-channel digital videos, shown on wide, flat-screen Sony monitors, were influenced by one of his mentors, video pioneer Doug Hall. Yes, Morales was born in Tijuana, but his cultural identity is a complex mixture of experiences and eras, making his work all the more powerful.

Rather than feeling devoid of a single culture, I started to see myself as a collection of fractions, borrowed from an infinite array of sources. They manifest themselves in my work as well as in the way I talk, eat, dress, and act. This is not an apology. On the contrary; it is a realization that I have access to, and more importantly, appreciation for all of these things that I admire and acknowledge as compelling. I do not try to "become" a Mexican or a lesbian or a Buddhist or an intellectual. Instead, I absorb facets, consciously or not, into what I hope is my own unique mixture.

By seeing ourselves as having complex cultural identities, we might even help to dispel overly simplistic categorizations. In his 1997 piece "On

Cultural Identity," essayist Richard Rodriguez wrote, "Because of so much immigration from Latin America, it seems easy to believe that there is such a thing as a Hispanic culture. . . . But as politicians have found, there's no single cultural experience uniting all Hispanics. It's possible as Hispanic numbers grow that the slipperiness of the label will seem more apparent to Americans. . . . In the meanwhile, we go around talking about Asians and Hispanics and Blacks imagining neat distinctions in borders where they may not exist."

The explanatory wall text for Morales's exhibition ends by stating, "[He] understands first-hand the ways consciousness shifts and morphs as it moves between languages, cultures and political systems." Instead of seeing myself as limited to a single, static cultural identity, perhaps I am part of that ever-changing cultural consciousness.

Exhibiting the Complexity of Culture

According to the 2000 U.S. Census, nearly one American in five speaks a language other than English at home. After Spanish, Chinese is the language most commonly spoken, and growing fast. This did not surprise me until I realized that with the exception of three students during all my years of teaching, I do not know anyone personally who speaks Chinese.

In the chapter "Identity and Authenticity," I write that Americans, exposed to so many cultures, absorb everything from mannerisms and gestures to ideas and beliefs. Culture is sticky, and we all pick up nuances that become part of who we are. But as I consider my lack of direct contact with Chinese culture, I see the limitations of my exposure to, and the way I learn about, other societies. Most of what I know about China's contemporary life has been limited to headline news, which is primarily about China's effect on the global environment and economy. Fortunately, by going beyond the common denominator of mass media, I am expanding my sphere of knowledge. I am learning more about China's culture through the venues that I believe provide more illuminating points of view than mass media: my own country's cultural institutions.

A nation as complex as China—with its rich ancient heritage, extreme political transformations, and rapid change and growth—is most profoundly represented by the arts. This complexity is deeply considered in

the cultural institutions that support and present the work of contemporary visual artists, playwrights, composers, and choreographers who explore their culture in their individual voices. These institutions are especially significant today because they provide both historical and contemporary perspectives that are alternatives to what we learn in the mass media. We see points of view that are far more varied and multifaceted and often incorporate references, both political and artistic, to the past. In fact, contemporary artists (typically agents of change) are often the ones who insist on maintaining a link with their country's history.

The exhibition "Between Past and Future: New Photography and Video from China," presented at the International Center of Photography and the Asia Society and Museum, included a section titled "People and Place," which focused on the changes in China's urban landscape. One of the artists, Zhang Dali, photographed buildings throughout Beijing that were being demolished. Through the holes in the wall, some of which were made by Zhang in the shape of his own profile, you could see more demolition, plus monuments, palaces, and gleaming new skyscrapers. The accompanying catalogue stated, "Zhang's interest lies not simply in representing demolition, but in revealing the different fate of demolished residential houses from buildings that are revered, preserved, and constructed."

By viewing just one photograph, I saw a huge array of changes within the city, showing the past, present, and future. I saw the attempt by one individual to see himself in this landscape of change. I saw his selection of a very particular view to emphasize the contrast between what China's current economy honors and what it rejects. And I saw his contemporary combination of graffiti and large-scale color photography as his vehicle of expression.

The exhibition "Past in Reverse: Contemporary Art of East Asia" at the San Diego Museum of Art featured a number of the artists who have created contemporary interpretations of traditional arts and practices. Cai Guo-Qiang makes work with historical and simultaneously relevant materials and actions. His ambitious choreography of six skywriting airplanes at the Miramar Air Show served as the basis for a landscape painting using gunpowder, a material invented in ancient China and still manufactured in Cai's home city, Quanzhou. Cai's work is both performance and drawing, ephemeral and permanent. (Cai has become an international art star with

retrospectives in United States venues such as the Guggenheim Museum, Metropolitan Museum of Art, Seattle Art Museum, Smithsonian Institution, and Massachusetts Museum of Contemporary Art, to name a few.)

Cultural institutions that show the work of contemporary artists allow us to see the personal ways in which citizens approach their culture and how they make sense of it for themselves and for the world. Perhaps the strongest argument for learning about other cultures through the arts is to consider the ways that we, as Americans, are represented in other nations. Hopefully, there will be support for venues in the world that provide alternative views to the ones delivered by the mass media.

Respecting
Culture

Artists perform a sort of alchemy on culture. We take the raw materials and transmute them into something different. We borrow images, tools, patterns, and even sensibilities from foreign as well as familiar cultures, and use them as source material. We arrange and reconstruct these elements to craft messages and make metaphors. Anything from a simple cultural gesture (like a handshake) to an entire cultural era (like the '60s) can become the basis for a fashion trend or artistic statement.

What happens to culture as it passes through us? Do we alter the meaning of a symbol or pattern by changing its context? Do we even understand the meaning of the elements we are using? In America, we have access to representations of both indigenous and foreign cultures. More importantly, we *are* both indigenous and foreign cultures. Do we have free license to use them, or, if you did not grow up within a culture, does that mean you have no right to its vocabulary? Is Yiddish only for Jews?

The subject of cultural appropriation has been raised repeatedly. The practice is widespread, and depending on your point of view, it can be a serious danger or a politically correct non-issue. Artists and musicians (think Picasso and Paul Simon) have often incorporated foreign cultures into their work. Is this appropriation or creativity? There is such a thing as cultural wealth, and once it is has been offered to the public, the original owners have no other choice but to share its value and witness its transformation. At the

same time, sharing culture can instigate empathy and mutual growth, and both parties benefit.

Artists are visual communicators, and as such, must consider the complexity of using the elements of culture. When you construct a visual message, you make some prediction as to how an audience will interpret the pictures you have chosen. If you don't understand a cultural image, the message that you intend to convey might be dramatically wrong. Ignorance makes you vulnerable.

I experienced an example of my own ignorance, and subsequently the beginning of my own education, in the privacy of my studio. Years ago I came across a powerful picture in a magazine: six Muslim women wearing the burqa, all leaning towards each other. The photograph was visually stunning on many levels: its abstract composition, the simplicity and uniformity of the garments, and the anonymity of the women behind the crocheted grilles. I tacked it to my wall for inspiration.

This was just a month before September 11, 2001. On that day, my view of the image changed completely. What had once been a picture of beautiful shapes became a picture of my ignorance. I reread the text on the back of the page, and the words that had previously been so rare and distant—Islam, Taliban, Koran—were about to become part of my daily language.

The following month, through a widely distributed e-mail exchange, I found that many American women were taking a second (and third) look at the burqa, questioning their feelings about what the burqa represented, and how to express those feelings. The e-mails began with a call for solidarity: "On October 8, wear a scarf to support Muslim sisters." An immediate response came from an artist who felt that she could not participate, believing that it was important to honor the "very American ability of women to remain uncovered (undisguised, fully seen, and fully heard)." The e-mail exchange continued, each message shining a light on the complexity of this and similar cultural symbols. I kept the picture of the women on my wall, and it became a different kind of inspiration.

As visual artists, we borrow and use images that already have connotations. When we incorporate the tools, artifacts, symbols, and sensibilities of diverse cultures, it is imperative that we try to understand them from a wider and deeper perspective. I believe that culture is at the root of the way visual artists work. The more knowledge and awareness we have of the ways we use culture, the better and more honest our work will be.

What's
in
an
Arch?

When you visit a new city, do you get a charge? Does the feeling come from entering into its density, immersing yourself in its tight maze of buildings, signs, transit, and people? Is it the constant motion around you? Is it the anticipation of all the things that are going to inspire and stimulate you, like museums, theaters, bookstores, and street life?

Those are the things that always provide the electricity for me. But when I drove into St. Louis, Missouri, in the middle of a cross-country trip, there was a new component that had a powerful and unexpected effect. I fell in love with the city because of an arch.

St. Louis's Gateway Arch is overwhelming as an identifier. It is the city's symbol and backdrop, and has provided a prefix or logo for many of the town's businesses and organizations. Taxicabs, dry cleaners, youth groups—so many of them lay claim to this image.

I was surprised by my reaction to the arch. Just because of this elegant structure and its surrounding park, I was predisposed to love the entire city. It presented a place of beauty, a vast open area that extends its reach into the sky. Subconsciously or not, I was convinced that this must be a great city, because it initiated, built, and celebrated something of such grace.

I was already a fan of Eero Saarinen, the architect who designed the arch. You're probably familiar with his work: the TWA (now JetBlue) terminal at the JFK International Airport in New York, the Dulles International

Airport near Washington, D.C., Kresge Auditorium at MIT in Cambridge, Massachusetts, and the John Deere & Company headquarters in Moline, Illinois, to name a few. The last building Saarinen designed (he died at the age of fifty-one) was the small North Christian Church in Columbus, Indiana, which he claimed as one of his best.

One of the fascinating aspects of the Gateway Arch is the time lapse between its design and its actual construction. Saarinen entered and won the architectural competition for the Jefferson National Expansion Memorial in 1947. This award is often considered his first great triumph. The irony is that although Saarinen died in 1961, the construction of the Gateway Arch did not begin until 1963, and it was not completed until 1965.

This got me thinking about the effect of this odd time warp. When Saarinen designed the arch, it was radical in its modernism. The buildings that he subsequently designed and built throughout his lifetime actually paved the way for his first to be an instant classic. In other words, his design was ahead of its time, but his further work installed modernism as a tradition. By the time the arch was finally built, it was no longer a risk, but a legacy.

Imagine yourself creating a design or artwork that is too radical to be accepted, and then your work over subsequent years influences the field to such an extent that your earliest work is considered groundbreaking. (Unfortunately, its early date could be overlooked, and in a contemporary context it might just be considered normal. It really makes you think about the meaning of "timeless.")

After spending the morning touring the visitors' center of the Jefferson National Expansion Memorial and riding the tram to the top of the arch, I decided to give equal time to another St. Louis landmark: the Anheuser-Busch (Budweiser) Brewery Tour.

I was underwhelmed by the tour. I saw horses in luxury stables, films of marketing campaigns, and big metal vats behind glass. The only beer I actually saw was in the tasting room at the end of the tour. After two free Buds, I felt a bit more kindly towards the company and began thinking about what it provides to the city of St. Louis, especially in contrast to the Gateway Arch. Rationally, it provides much more. It's not only a huge contributor to the region's economy, it also provides more jobs, philanthropy, and outreach programs, and it creates a tangible product.

The arch, by comparison, provides few jobs and little income to the

city. Of course, it creates income for surrounding businesses because it is a tourist draw; press literature states that "millions" of people visit each year. But still, the arch itself has no actual function, other than housing an elevator that carries people 630 feet up for a great view.

What's in a Monument?

What is it that makes an essentially nonfunctional, man-made structure so forceful? Monuments like the Eiffel Tower, the Statue of Liberty, and the Washington Monument were built to inspire viewers to ponder themes such as liberty, innovation, exploration, and democracy. Can a structure whose main function is to act as a symbol actually be important to a city's life? Does a monument give a city its identity? And does the city then in some way have an obligation to keep and live up to that identity? Is the monument for the inhabitants, or is it for tourists? When does it become the backdrop in a postcard or the model for a hotel in Las Vegas?

In time, does the theme that the monument symbolizes matter more or less than the structure itself? It must depend on what the monument represents. The Gateway Arch was built to symbolize St. Louis as the gateway to the new frontier. But I wonder how many individual citizens of St. Louis gaze upon the arch and say, "I stand at the starting point of new exploration."

Of course, the Statue of Liberty still carries enormous power for many people who live in and visit New York, and they do see it as an icon of freedom. It is always a powerful symbol, and has periods of intense resurgence, depending on the world's events. Many believe that the Statue of Liberty is actually an influence in compelling the citizens of New York to welcome new immigrants. Hopefully the new structures that are planned to replace the World Trade Center will portray and affect the identity of New York City in as compelling a manner.

I once attended a lecture by Jon Jerde, the well-known architect whose designs include the 1984 Olympics in Los Angeles and the Bellagio hotel and casino in Las Vegas. Jerde showed pictures of a building that had many people milling about and interacting with one another, and the structure seemed to be the anchor of that activity. He encouraged the audience to think beyond the physical structure and to consider what it allowed and even encouraged to take place between people. He said, "The structure is expensive, but the space between is free."

Perhaps that is what is most powerful about a monument. The structure itself is just the beginning. Its purpose is to elicit and inspire an individual to carry the symbol in whatever way is most personally meaningful, whether it is a symbol of innovation, remembrance, democracy, or simply beauty.

Constructed
Walls

I like being alone in public places. It's a big part of my life. I spend a lot of time looking, particularly at people. I especially like looking at other people who are alone in public, doing the same things that I am doing: walking, drinking coffee, writing or sketching in a notebook, or just daydreaming.

Each of us has a private space that we occupy when we are in public. For artists, this is fertile ground for inspiration. We are simultaneously immersed within and removed from humanity.

We often build virtual walls, consciously or unconsciously, to allow that inspiration to roam and develop. Sometimes we create these walls by using technology like iPods, other times simply by retreating to a private place in our mind's eye. In either case, we each make the construction individually, by our own choice. This is one of the most precious liberties I know: freedom of thought.

A few years ago, I went on a two-week trip to Eastern Europe. Like most tourists, I sought out the remnants of—and references to—World War II and the subsequent authoritarian regimes. As we toured different cities, I often heard, "This whole area was rubble," or, "This was the train station where deportation occurred." I saw pictures and diagrams of bombed or torched buildings with less than half their structures left. But in front of me, in actuality, I saw brand new office buildings and malls designed by

contemporary architects and renovated churches and synagogues that were replicated as closely as possible to the originals. As places like East Berlin become more westernized, i.e., more modern and commercial, the physical evidence of past destruction and repression continues to disappear. But as that evidence disappears, there is the simultaneous building of memorials of remembrance.

Partly because of my background, I have always been mindful of the need to remember the murders carried out by the fascist and communist regimes in Eastern Europe. But what I experienced, mostly by spending time at these newly built memorials, was a more visceral reaction to the enormity of the *psychological* devastation. The power of each of these memorials was in its ability to intensify the feelings that I experience when I am alone in public.

The first memorial I saw was in Berlin: the Memorial to the Murdered Jews of Europe, designed by the architect Peter Eisenman. When it opened in May of 2005, it was described by reporters as "an undulating labyrinth of tilting stone plinths, covering 204,440 square feet with 2,711 slabs of varying sizes and heights." At first, I saw only its sculptural beauty. (I was not surprised to hear that Richard Serra, the sculptor, had been involved early on.) My reaction had nothing to do with the content, i.e., the message, of the memorial. But as I walked through, I began to feel the intended effect; I was faced with disorientation and the slight claustrophobia of being in tunnel-like spaces. While I was there, kids were playing hide and seek, jumping out unexpectedly in front of me. I've heard there is a reference to the cemetery in Prague where the ancient headstones have all tilted to different angles. For me, however, the intensity came from physically wading into the space, losing peripheral sight, and being forced to watch my step—literally.

Also in Berlin, we visited the Jewish Museum, designed by Daniel Libeskind. Inside the museum, we entered the Holocaust Tower—a high, narrow, concrete room that had an extreme effect on my senses. I experienced the space through touch, sound, and smell, plus a minimalist sliver of window for sight. My senses got confused; it smelled cold. The space projected me into the minutes ahead: all I could think was, how long do I have to stay in this uncomfortable room?

Several days later, in Vienna, we sought out the Holocaust Memorial designed by the sculptor Rachel Whiteread. Again, I went there thinking more about the "art" than the events it represented. And again, the physicality of the work brought me to its intention.

In this monument, the empty room that walls would typically enclose is, instead, filled in. The monument is a concrete cast of the interior of a library. In a BBC interview, Whiteread said, "it was as if one of the rooms from the surrounding buildings had been taken and put in the centre of the (Judenplatz) square, and all of the books were completely blank. . . . the pages were facing outwards so you couldn't read the spines of the books." Looking at the monument, I was conscious of the space that had been taken away and filled in, making it inaccessible and at the same time suffocating. I felt closed out.

The next morning, having coffee in my hotel, I thought about White-read's "library room" in terms of a public library, one of the best examples of a space that is both public and personal. A library is a very solitary place, but also the most public. The books and space are shared, and at the same time it is an atmosphere that is utterly respectful of privacy. It is hushed (picture the librarian, her fingers to her lips) so that one's thoughts won't be interrupted.

We each look at the world with our own filters. In my own privileged life, there has rarely been a wall—physical or psychological—that truly curtailed my freedom. My personal walls are built by me, by choice. On my trip, I saw these monuments as metaphors for cities where the personal spaces were others' constructions and were made not to protect freedom of thought but to annihilate it.

During our visit to Prague, we took a bus to the town of Terezin. Here was a different kind of memorial: not renovated, not newly designed and built, but instead a preservation of a town. People live there now. It looks, to the uninformed eye, quaint. However, its role in the years 1940 through 1945 was devastation. It was used in Nazi propaganda films to depict their so-called "beautification" campaign: a "self-administered Jewish settlement territory." In fact, it was a transit camp for Jews before they were sent to other concentration camps, and it was also a place of death.

An elderly gentleman accompanied us to help guide our tour. When he was nine years old, he had spent six months in Terezin, and was then deported to Auschwitz. Before our group got back on the bus, I lingered at the edge of the peaceful, quiet park in the center of the town. I felt inspired by the profound feelings that I was experiencing. As I looked at the trees and my thoughts began to roam, I heard our guide say, "We were not allowed to go there."

3

LIFE

SUPPORT

*First, listen. And then say, "Yes, and . . ." In other
words, pay attention to what your partner is doing,
and then use her action to build upon.*
—Two fundamental rules of improvisational theater

First,
Accept
No
Harm

Early on in my career, I was given what should have been the plum job of designing a poster for an upcoming public event. My boss handed me the assignment with a few scribbled sketches and said, "If I had the time, I would do this, but I can't do everything." He made it clear that I was a poor substitute, but I would have to suffice. I spent most of my time trying to figure out what he would have designed, unconsciously rejecting everything that was unique to my own vision or capability.

We all know how important it is to have support in our careers. Many of us have been lucky enough to have mentors, colleagues, and family members who enable us to fulfill our goals, whether their support is financial, emotional, or intellectual.

We also have people in our lives who have impeded our progress. Just as we need to seek positive support, it's also important to strengthen ourselves against *lack* of support—against criticisms that are doled out lightly but cripple our passion, and against negligence that leaves a prolonged bitterness. One of the most crucial—and difficult—goals in your career (dare I say, life?) is to be clear about what you want and hope for: to declare, defend, and pursue what you want. Sometimes this means identifying that which holds you back, and seeing how insidious lack of support, in all its guises, can be.

The most egregious examples are the situations that take advantage

of vulnerability. Sometimes they are so hidden that we barely know it, and we naively contribute to our own erosion of confidence.

Here is one experience that may sound familiar to many of you. A young woman in art school had a teacher who showed a lot of interest in her work and praised her inventiveness. She was eager to please, and hungry for every bit of extra advice, until one day the "advice" came in the dark computer lab. She pulled back and consequently began to receive much less attention. His praise dried up, and so did her confidence.

The links between ambition and sex are obvious; they are about wanting power, having power, and the bargains that go on between the two. What I want to illuminate is something subtler: the link between hope and vulnerability. When you have passion and great hopes to do good work, you're in a particularly vulnerable state. When you look to authority figures for validation, you tend to give their actions and remarks much more weight and consideration than they do in delivering them.

Sometimes, ironically, lack of support comes from a person who is devoted to you and your well-being. When you turn to people close to you for support, it's likely that they will advise you according to their own points of view, needs, and beliefs. It is rare—maybe even impossible—for someone to advise you based totally on what *you* need. Parents' advice may be protective, driven by the wish for you to choose an easier path. Or they may think you are capable of more (in their terms, that is) and thus criticize you for not doing enough. Husbands or wives may see your desires as conflicting with their own or have a definition of success that differs from yours. The people who are close to you may not realize that certain habits and conditions are deeply necessary to you and cannot, must not, be cut short. When I try to figure out, and then try to do, what someone else wants, I fail. But when I focus on what I want and how I want to do it, I succeed. If you're lucky enough to have people who care about you, it makes sense for you to articulate and express your needs to them, even if you simply agree to disagree.

And then there is the general, atmospheric lack of support that comes in a much less personal form: society. This is especially true in the United States, where the arts are undervalued as a profession. How many parents do you know who, when faced with their child's question, "Should I go to medical school or art school?" would really recommend art school? I have a friend who has two daughters: one is pre-med and the other is pursuing an MFA. The majority of people he knows say of the med school daughter:

"How lucky you are; what an accomplished young woman." Fortunately, he is equally proud of each daughter—probably because he is a designer and an artist himself. He is supportive, but society is not.

I find this particularly subtle. People in the arts get a continuous, unconscious message that their work is unimportant, self-indulgent, and unworthy of fair monetary compensation. This negative atmosphere can manifest itself in a creative blockage. It's like sleeping on a bad mattress night after night and wondering why your back hurts. To be perceived as a failure, even when that perception is not directed at you personally, can erode your passion and ability to produce. At the very least, the amount of energy it takes to negate it is significant.

We have different needs in terms of support and, by the same token, we have different ways in which we are vulnerable. We are all supporters and supportees, and often there is not a perfect match. As much as I try to be supportive, there are many people who do not benefit from my perspective. As my co-teacher and friend once said when we discussed how many students we were able to help, "You can't reach every one of them." However, we both agreed that no matter what, we should do our best to clear the runway of obstacles.

In Lawrence Wechsler's book *Seeing Is Forgetting the Name of the Thing One Sees: A Life of Contemporary Artist Robert Irwin*, Irwin explains that his teaching is focused on helping each student to develop her own sensibilities. He says, "I think the most immoral thing you can do is have ambitions for someone else's mind."

One of the first things that a medical student learns is the Latin phrase *"Primum non nocere,"* which means, "First, do no harm." Perhaps those of us in the arts should find the equivalent phrase for, "First, *accept* no harm."

Muriel
Cooper

Muriel Cooper died on May 26, 1994. She received innumerable international awards acknowledging her accomplishments as design and media director of MIT Press, and as co-founder and director of the Visible Language Workshop (part of MIT's Media Lab). Her work as a designer, educator, and researcher spanned almost fifty years and repeatedly challenged and redefined the standards in visual communication.

But when I learned of Muriel's death, I didn't think about all of that. I thought about me.

Muriel was my mentor. She had more influence on shaping my career than any other person or set of events in my life. When I think of the number of people who echo these same sentiments about Muriel (hundreds!), I am even more overwhelmed.

You remember this feeling: you are young and you are on the edge of discovering who you are and what you want to be. You're close to it, but you can't articulate it. Then, one day you go to a lecture, or a class, you hear a teacher's words, and you say, "Yes! She's talking to *me*!"

Who has been a mentor to you? Have you been a mentor to someone else? Since Muriel's death, I've often thought about this: What makes a mentor?

To find the answer, I look back some thirty years, when I worked for

Muriel at MIT Press, then followed her to the Visible Language Workshop (VLW) at MIT as her student and teaching assistant.

Encouraging Collaboration

We live in a litigious and competitive society, and artists of all types are accustomed to worries about infringed copyrights and stolen images. These thoughts were foreign at the VLW. One friend who was at the VLW for many years told me this: "We shared everything: pictures, software code, equipment. We were flattered when our images appeared in someone else's work. I remember a little piece of code I wrote and lost, and someone else found it and used it. That was wonderful!"

In my first course with Muriel, "Messages and Means," we were taught to run an offset press. We divided into groups of four, and we each created a quadrant of a plate, which we then rotated to create overlapping effects. All successful prints were due to our combined imagery. Not long after that, Muriel encouraged me and many others to collaborate with software programmers. Student projects took on a permanence and were used in subsequent work in the Media Lab for years.

Muriel was constantly lending students her personal equipment, including expensive cameras, video decks, tape recorders, and Polaroid cameras. She was a shopping maniac and had drawers full of complicated gadgets. She shared them all, especially if you could help her figure out how they worked.

Engaging Intellect

One friend told me about a lecture he had attended in 1979 titled "Pluralism in Graphic Design in the '70s." He watched the first three speakers simply show their portfolios as he waited for someone to address the topic. Then, Muriel got up. She showed the clean, beautiful, modern posters of MIT's Design Services. Next, she showed slides of these posters in the halls of MIT, obscured by a cacophony of Xeroxed flyers and announcements created by the MIT community at large. Her point was that all people, not just designers, had access to tools with which they could create printed communication; they used copy machines, Letraset, IBM composers, etc. (She made these prescient remarks in the 1970s, before personal computers existed.) My friend visited Muriel at the VLW the day after this lecture, and he stayed for years.

Muriel encouraged me to see the bulletin board as a place where the

design of a poster is no longer controlled by its creator. It takes on a life of its own. As a result of her direction, I designed a 24" × 36" poster that left the middle of the sheet blank. I printed a bunch and pinned them up all over MIT. Every day, I watched the ways the community used or ignored the white space. With Muriel's guidance, this led to my interest in interactive media.

A more recent VLW student told me that he changed his entire thesis plan based on one sentence from Muriel. His thesis concentrated on applying computer-assisted intelligence to the layout of the printed page. Muriel told him to look at the dynamic aspect of the computer medium: How do you develop a program to design information that is constantly changing? (This is one of the most important questions that designers of interactive media have to address.)

When Funds Are Short

I had no idea back then that it was not possible to dip into the institutional piggy bank and take what you wanted. I look back now in awe at the equipment, talent, and materials Muriel was able to collect—usually on loan, for barter, or because someone simply wanted to contribute. When I worked for Muriel at MIT Press, I started at four days a week. I loved it. After a while, I said, "Muriel, I want to work five days a week." She said, "Great! Do it! But you know, I can't pay you for any more than four days." Well, I had my pride, so I told her I would stick to my four days. But I snuck in every Saturday and worked all day.

The VLW had a continuous migration path to increasingly more powerful workstations. New ideas that incorporated 3-D and higher resolutions required sophisticated technology in order to be realized. Muriel made sure that the technology was available to her students. Period.

New Definitions

I was attracted to Muriel's messiness. To me, this meant that she gathered ideas and materials and people and put them all in front of us, and we made our own order. We were encouraged to create unusual schedules and to define, name, and even help to write the curriculum for courses before we enrolled in them.

I was inspired by her clothes. They were unstructured, too—layered, loose, and comfortable with lots of pockets—places to hold scraps of ideas.

Looking Outward

Muriel created links to all of MIT, as well as to the outside world. This was the roster of departments represented in one of my classes: Architecture, Urban Planning, Artificial Intelligence, Film and Video, Center for Advanced Visual Studies (CAVS), Engineering, Cognitive Information Processing Group (CIPG), and the Architecture Machine Group. These were not people who met once a week and then separated; these were people who worked and made things together.

I remember one semester when we students created a journal, developed a poster series for a show of student work, created the pieces, set up the exhibit, documented the show with every form of media available to us, and then figured out how to publicize it on MIT's cable television station, using fonts that we had developed.

Muriel enabled this and more. She convinced many people who subscribed to science, engineering, and quantifiable things that visual communication was of equal importance. And imagine what she represented to the small batch of women at MIT, who watched her stand her ground in a predominantly male establishment. She did all of this so that her students could participate in, even *define*, the future of visual communication.

What do we consider to be our greatest accomplishments? Winning awards? Authoring books? Designing groundbreaking products? Exhibiting our work at prestigious museums? Think of this: Muriel Cooper created an environment where literally hundreds of people discovered, pursued, and realized their passions.

Muriel presented the work of the VLW at the TED 5 conference in 1994, where it was greeted with, as one friend said, "a communal gasp and a standing 'O.'" The demonstration showed the translation of complex electronic information into a compelling and comprehensible landscape. But the most vivid image in my mind is not of any screen; instead, it's of Muriel, describing the work of her students with pride and commitment.

Look at your own résumé and think about what is behind your best accomplishments. Do you see someone there, someone who encouraged you to push harder, explore, and discover? And do you see the role you have played in inspiring someone else to explore an uncharted course?

As I look at my résumé I ask myself this question: *What could be more important to add to it than "Mentor"?*

Designing the Self-Critique

We are all hungry for critiques. We want to know what our teachers, colleagues, bosses, and collectors think of our work. Good, honest feedback provides a fresh perspective that will help us to grow.

Recently, after a long and thorough critique, a student of mine said, "It's great to get this help in class. But what about when I'm by myself? How do I *self*-critique?" His question was startling; it was about something so obvious, so necessary, and yet so neglected. It is especially important for students who are about to graduate. They need a practice that will sustain self-reflection long after graduation.

As an artist—whether your work is commercial or personal—you probably spend a large portion of your time working alone. You have an intimate connection to your work. You know how it started, how it developed, what you kept, and what you discarded. The audience, however, sees only the final piece. Does your intention come through? Are your ideas communicated? One of the hardest tasks in the creative field is distancing yourself enough from your work to be able to judge it objectively.

Think the Opposite

One of my most memorable graduate school conversations consisted of three sentences. I said to my instructor, "My work is too minimal." He said, "Try thinking the opposite." I said, "Okay, my work is not minimal enough."

He left, and I immediately began to look at my work differently. I made it more minimal, stripping away to the essential. At the same time, I accentuated visual details that suggested a narrative. In other words, I became more aware of both ends of the spectrum. Now when I am working alone, I often repeat the phrase, "think the opposite."

Put It Up

Display your work-in-progress around your home, in places like the bedroom or the bathroom, where you will see it first thing in the morning. Confront it. I find that I get an immediate gut reaction, a clear thumbs-up or thumbs-down. After a while, it becomes invisible. That's the time to put up the next iteration.

Paste It in a Publication

One way of seeing your work more clearly is by placing it in a new context. I mean this literally. Trim a piece of your work to fit the grid of, for example, a magazine you admire. Paste it in, put it away, and go through the magazine later. Seeing your own installation, illustration, or photograph as though it is a published piece helps to illuminate its flaws, its virtues, and its relevance in our contemporary culture.

Recreate It in Another Medium

In the chapter "Another Kind of Language," I quote the artist Richard Serra: "When you want to understand something, you have to take it apart or apply another kind of language to it."

This exercise requires time and commitment. Select a project you are working on. As a simultaneous project, recreate that same work in another medium. For example, if you are a working on a series of photographs, experiment with redoing that series as a video or as drawings. If you are a print designer, try recreating the brochure you are working on as a Web site, or even as a spot on the radio. Try not to judge quality. Concentrate instead on the ways that working in this new medium differs from your normal process.

I'm a fan of David Hockney, and I rented a video entitled *Portrait of an Artist: Hockney the Photographer*. Hockney was first and foremost a painter. He didn't think much of photography. He said, "The main aspect was this lack of time in the photograph. . . . Compared to a Rembrandt looking at himself for hours and hours . . . there are many more hours there than

you can give it. A photograph is the other way around. It's a fraction of a second frozen. So, if you look at it for even four seconds, you're looking at it for far more than the camera did."

Hockney decided to exploit this limitation. He developed a technique he calls "joiners." He took a series of individual photographs of a scene over time and pieced them together to create a two-dimensional map of time and space. By applying another kind of language (photography), he investigated the passage of time in a new way. He continued to build on this work, and also used his discoveries in his painting.

If you try these exercises, hopefully they will help you to gain new perspective—to see your own work from a distance, with fresh eyes, even when you are deeply immersed in a solitary endeavor.

Components
of
Collaboration

When we picture a collaboration, we usually focus on the completed, tangible, public product, whether it's a book, a play, a film, or an organization. But there's another "product" that deserves its own recognition: the process of the collaboration itself. When I reflect on my collaborative partnerships, I realize that each one has components that are well worth articulating and are as important to record as any product in my career.

Making the Connection

A collaboration may begin with a specific idea, where one person seeks complementary partners in order to carry out the project. But for me, the opportunity to work with a particular person is the strongest impetus for initiating a collaborative effort. I've been involved in a number of creative partnerships, beginning with Chris Schmandt at MIT's Architecture Machine Group in the early 1980s, when we developed "soft" typography specifically for the computer screen. In another early collaboration that focused on innovation in technology, Paul Souza and I co-founded and co-directed the Design Lab at WGBH to develop design principles for interactive media. In both endeavors, I was first drawn to my collaborator's unique sensibility, enthusiasm, and dedication.

A few years later, Ceasar McDowell, founder of MIT's Center for Reflective Community Practice, and I developed courses involving media and

creativity that we taught for six years at Harvard and MIT. Our partnership began with a conversation about our own work, goals, and interests—basically, just talking about our lives. We soon realized that by exploring our common and complementary aspirations, we would be able to expand our own creative voices. We saw each other as catalysts. The decision to develop and teach a course together was a natural step.

I began another kind of collaboration with Martha Mason, artistic director of Snappy Dance Theater. Our eventual "product" was twofold: a new dance work and a book of photographs and essays. As with Ceasar, the impetus for generating a project with Martha came from our knowledge of each other's ideas and work. Long before we settled upon tangible products, we had a mutual goal: to push our respective work into unknown territories by sharing our artistic vocabularies.

Years ago, I found a book edited by Barry Daniels, titled *Joseph Chaikin & Sam Shepard: Letters and Texts, 1972–1984*. The first time I read it, I focused on the work they had produced together: several theater pieces and performances. Now, as I pay attention to the interaction between two people, I am seeing the components of the collaboration. An essay by Eileen Blumenthal (in the book) includes a description of the way Chaikin and Shepard began working, noting that they had no specific themes and no usable text. "Almost nothing," Shepard says, "but a desire to work together." As I read more, I recognized that "almost nothing" was actually a deep respect, knowledge, and familiarity with each other's work. They knew that they shared a sensibility, and they trusted that whichever themes they eventually chose would not only hold their interests, they also would enlarge their individual visions.

Conversations

Everyone has her own reaction to a blank sheet of white paper. For me, it represents freedom and one of the most enjoyable phases of my work, a time in which I allow myself to play, mess up, and digress like crazy. I've found this to be a common theme in many people's early stages of a creative endeavor. It's the warm-up.

I look for the equivalent in the beginning of a collaboration. We start with a long, rambling conversation about anything that is currently important to either one of us. Ideally, we have a stretch of time that's not

squeezed between other appointments, and, if we're lucky, we're at a beautiful location. After hours have passed and we both need to go to our respective homes for dinner, we realize that we haven't "produced" anything. Then, within that last half hour, the work seems to pop out.

Often, the benefits of the conversation continue. As I keep my creative partner in mind, the dialogue keeps going even when I'm alone working. I see that person and have a "discussion" about an idea. It extends and affects my own imagination by providing another perspective, or at the very least, a vessel into which I can direct my thoughts.

The Interview Tool

Once, when I was having a terrible time trying to form and articulate my ideas for the classroom to Ceasar, I said in frustration, "Ask me questions!" He did, and it felt like a breakthrough. I learned that the most generous thing you can do to help someone with his work is to ask questions. This is more generous than giving opinions; it's a way of helping the other person to reflect and clarify what his work is about.

I had never actually named this technique until Martha pointed it out during one of our work sessions. It was a beautiful spring day, and we went to the ocean to work. After talking for a couple of hours, we separated to write up our thoughts. Martha's notes began as follows: "It is now that time in the process to narrow down our creative play, and to shape the developing themes in both the choreography and the photography. Walking along the beach to the shelter of large rocks, we began a round of 'interviews' with each other, a tool Wendy introduced to help us see things about ourselves that we might not have before. For instance, being asked to describe my process, it became clearer to me by having a sounding board." Her questions to me, which were about the symbolism and meaning in my photographs, forced me to look at what I had been taking for granted. The exchange of a few simple but insightful questions produced valuable reflections and subsequent directions.

"Yes, and. . ."

I also use an approach that I learned years ago from an actor who often performs in improvisational theater. He taught me two of the most important rules of performing improvisation: first, listen, and then say,

"Yes, and. . ." In other words, pay attention to what your partner is doing, and then use her action to build upon. The point is to construct a supportive environment that encourages beneficial results.

To me, saying "Yes, and. . ." is being positive, supportive, open, and (how convenient!) productive. In a *New Yorker* article by Larissa MacFarquhar, "The Better Boss: How Marshall Goldsmith Reforms Executives," Goldsmith describes "one of his rules for the receiving of ideas in general: never start a sentence with the word 'no', but', or 'however.'"

I'm sure you have seen creative brainstorming sessions where people are nervous about voicing their ideas for fear that they will be received negatively. The intention of "Yes, and. . ." is to acknowledge that every idea can spawn another, and that each one is therefore valuable. Martha says of her process, "It is important to create an emotionally safe and playful environment where each dancer feels inspired, creatively generous, and eager to contribute."

Respecting Individuality

What is the role of the artistic ego in a collaboration?

One might assume that the main reason for a collaboration is that it will produce a better product than one could alone, i.e., "the whole is greater than the sum of its parts." But I believe that the goal—and challenge—is to have both: great individual parts as well as a great whole. It would be silly to deny that each participant wants her work to shine in its own right and not be overshadowed by the collaborative product. Each individual must, in the end, still be recognizable, while simultaneously being part of an integrated whole.

As Ceasar and I refined our classes over the years, we found that we were inevitably strengthening our individual voices and direction. Our respective expertise and interests became clearer, which was useful for us as well as for our students. We incorporated each other's visions into our own, and, along with the product of a new curriculum, we each gained a more robust and meaningful career.

The Translation Process

I mentioned earlier that a partnership allows the sharing of artistic vocabularies. While each person wants to absorb the other's language, there is still the desire to translate it back to her own.

In my collaboration with Snappy Dance Theater, Martha's company

members improvised using my studio space and "props" from my previous installations. During our improv and photography sessions, a creative dialogue transpired: the props and the studio space influenced the movement, which then influenced the photography, which in turn influenced the movement, and so on.

Martha and I started our work with the notion that we would experiment with trading "disciplines." I would put my body into the movements; she would view the improvisations through the camera.

It didn't take long to realize that everything we saw and did was immediately and irresistibly translated into our own respective disciplines. When Martha looked through the viewfinder, she was not thinking about making a photograph, but about making a dance. And when I joined the dancers, I was not thinking about choreographing movements, I was imagining ways of portraying physicality in two dimensions. We used each other's tools to go further with our own work. In this sense, collaboration is about creating a shared experience that promotes mutual growth: moving side by side, ricocheting back and forth.

A Continuing Influence

A collaboration's finished products are the tangible representations of the individual and joint work. Along with those tangibles, there is a process that has a life of its own. Even after a project is complete, the process continues to influence one's work and will even go on to play a role in future partnerships. My current collaborations make constant use of previous lessons and often involve people I have worked with before. Alternative forms of working, learning new languages, and gaining perspective are just a few of the powerful components of a collaboration. Best of all, the insights and influences continue to grow.

Your
Portrait
or
Mine?

When Ceasar McDowell and I co-developed a new class at the Harvard Graduate School of Education, we approached the curriculum from two very different perspectives: I was concerned with supporting artistic self-expression, while Ceasar's focus was to support the expression of a community. Our title was a near-literal representation of our combined interests: "Media & Technology: Supporting Expression of Self, Community, & Culture." The first line of the syllabus stated, "We live in a society in which we as individuals have access to the tools and distribution outlets of media. But do we use these assets to support creativity, learning, expression, and voice (our own as well as others')?"

The primary project was "Expressive Portraits." We asked the students to choose a person—a "citizen"—about whom they would create a portrait. How do you develop and portray a representation of a person? It's an incredibly complex task. You want to express the subject's view, but you also want to express yourself. You want to collaborate with your subject, but you want artistic control. You want to get at something provocative, but you want to represent the individual in a good light.

As the semester progressed, the students' work identified one of the most important aspects of the course description: supporting your own expression as well as others'. As an artist, when you are creating a portrait, whether it is a portrayal of an individual or a documentary about a

community, there is the inevitable question of artistic control. Wide-ranging choices regarding aesthetics, privacy, and point of view must be made. As your working relationship with your subject gets deeper and more involved, making these decisions becomes increasingly difficult. Throughout the class, issues of representation and responsibility were at the front of everyone's consciousness. Ceasar and I did not introduce these questions ahead of time; they came up naturally and irrepressibly.

Self Expression Versus Citizen's Expression

There was a wonderful spirit of collaboration between author (the student) and citizen. Relationships grew stronger as people learned more about themselves and each other. But conflicts arose when a citizen's preferences didn't match the author's. Sometimes the conflict was about the flow of the narrative (when, for example, a citizen wanted to include elements that the author felt unnecessary). Sometimes it was an aesthetic preference: one student wanted to create a video that was abstract, frenetic, and very conceptual, but her citizen wanted a humorous, slow-paced, easy-to-follow story. Sometimes it was a deeper conflict, about, for instance, revealing religious attitudes. As they grappled with representing the citizen's expression instead of (or in addition to) their own, students were reminded of other aspects of their lives where they had to challenge their own biases.

Because the students' primary goal was to support their citizens' expression, they were more protective of their citizens' representation than of their own. In each case mentioned above, the student chose whatever was most appropriate to the citizen. One student worked together with her citizen on every aspect of the project specifically to avoid having too much input and control.

Exposure Versus Privacy

As the portraits progressed, the angst came out. Will I represent this person fairly? Accurately? Too much? Too little? Often, the traits or circumstances of the citizen that were the most interesting were precisely the ones she didn't want to reveal. One student brought in a relevant article about documentary filmmakers titled "Truth and Betrayal in the Editing Room," written by Ted Conover in the *New York Times Magazine*. Though much more extreme than anything in the students' work, the story articulated their concerns. Conover wrote about the filming of a teenager

who admitted his own part in date violence: "This kind of intimacy is what *vérité* documentarians live and die for. But it's not always easy to get and it's not always something the subjects, looking back, are glad to have supplied."

All of the students faced a struggle: How much can I expose? Some were absolutely clear on the matter; they were not willing to jeopardize their relationships and chose to avoid anything touchy. One student had to give up his first choice of subject because of immigration concerns.

Another student, however, decided to highlight the issue of exposure, perhaps as a result of choosing a person whose primary requirement was privacy. What a challenging topic for a portrait! She solved the problem by focusing on it; privacy was a pronounced theme in her portrait. Few specific facts about the citizen were revealed. Instead, she created a physical representation of her citizen's office and invited the audience to sit in and use the elements in the environment, thus simulating the experience of *being* that person, rather than knowing intimate details about her. The portrait was a reflection of audience members as they participated in the citizen's "space."

Choosing Supportive Media

Because we encouraged the students to carefully consider different media, they were sensitive to the fact that a medium can be both an inhibitor and a supporter of expression. This affected their choice as well as their use of media.

One student put the medium in the hands of her citizen, a three-year-old. The little girl was comfortable using a camera, and took wonderful pictures from, literally, her perspective. But she was better at telling her stories without audio and videotaping to distract her, so the author listened to and transcribed her stories. Ultimately, the author chose to create a small book of the girl's pictures and stories as the medium for the final portrait; it was the best representation of her citizen's expression.

Being Seen, Being Heard

When we were planning the course, Ceasar and I had numerous discussions about the issue of being heard. One of the primary goals in our class was to determine ways that media and technology can be used to amplify, so to speak, a person's or a community's voice. We saw the complexity

of this endeavor in the portraits, especially in the little girl's book portrait. It was beautiful, and those who saw it were moved by it. But in the commotion of the exhibit, many did not realize it was there and didn't see it.

Is the loudest voice always the strongest? We know that often something that is small and quiet is the most effective, but what if it isn't seen or heard? What do we do to make sure that something or someone is not overlooked when everything else is bigger or louder—more present?

Process Over Product

Many of the students created various media pieces that were not for the final portraits, but for their own personal processes. In a reflection paper, one student wrote, "I created a video piece about my anger and left it out of the portrait. Instead of trying to suppress my anger, I expressed it, yet acknowledged that the citizen portrait was not the appropriate place to present it." A number of students employed video and audio as a sketching tool, using the tapes as information for other media, such as physical constructions, multimedia projections, or computer-based presentations.

Building a portrait is also about not predicting an end result, but instead allowing the process itself to determine the product. One student wrote, "You have to put the data together based on themes that often emerge throughout the process. Over time, you reflect back on the past and compare it to the present while still anticipating the future."

Another student wrote, "As we neared the time of the exhibit, my portrait continued to change at an ever-increasing pace. Decisions about media and form became more intuitive as I found myself with less and less time to intellectually debate the 'correctness' of my choices. Ultimately, I found that the layers in my portrait conveyed my own working process as well as my idea, vision, and feeling of my citizen."

This reminded me of a quote by Wayne Thiebaud (*Vision and Revision*) that I keep on my wall: "When an artist or viewer feels involved in a work, they relate to that work as a living thing, with a sense of exhilaration and freshness of spirit. It is primarily an intuitive process that can give the work a life force. In contrast, finishing off demands an intellectual process, a neat tying together of things in a way we 'think' is correct."

Thiebaud strives to forestall the "absolute resolution" of a work, which can be "dangerously close to the art of taxidermy."

When Media Freezes Time

One student's video recorded a transitional phase in a friend's life. But by the time she completed the editing and compilation of the portrait, her friend had moved beyond that difficult period. She wrote, "Although the camera records time as it is happening, it also freezes moving time. The content of that segment is no longer real, yet it is the data that I have to use to create. The content was history." As a "portfolio" piece for the student, this was not a problem. But she was concerned that her representation of her citizen had become misleading.

These are some of the thoughts and issues that were shared by the members of our class. As we worked on other projects, we continued to discover the importance and complexity of supporting expression by creating a tangible, lasting media product. As one student wrote, "Expression through media creates something permanent, and will always be there for ourselves and others to see. Simultaneously, it can change our lives as well. Will this capturing of a moment in time make that moment more important in (my citizen's) life merely because it has been captured and therefore can be retrieved? Expression is not simply reflection; it is also a proactive, conscious event that has consequences. Expression has power."

The
Work
in the
Exhibit

A course that involves the visual arts often culminates in an exhibition. This provides each student with a tangible goal: to show a completed body of work. When Ceasar McDowell and I first started teaching our course "Media & Technology: Expression of Self, Community & Culture," the primary focus was each individual's work and the exhibit itself was secondary. After four years, we came to realize that the exhibit was as important as the work.

Over the semester, each student produced a media portrait of a member of a community other than her own. The assignment addressed an underlying question of the course: how do you support your own expression as well as that of others? By creating a portrait of someone else, you realize how much you, as well as the media you have chosen, are a filter of someone else's expression.

The assignment for the class as a whole was to produce a public exhibition. As the students developed their portraits, they explored and discussed issues of responsibility, creativity, exposure, authority, and shared authorship, to name a few. The planning and staging of the exhibit involved similar explorations; they were less obvious at first, but perhaps even deeper.

Who Is the Judge?

In the classroom, the teacher is the judge and therefore the recipient of the students' efforts to please. In a public exhibition, the role of judge shifts to others: colleagues, friends, family, potential employers, other teachers, and hopefully the students themselves.

The students' exhibit was short—less than three days. This made it more of an event, and most students wanted to be on site as much as possible. Watching the audience was an eye-opener for them. A couple of comments: "How could they walk away before my video made its point?" and "They wrote in my guest book about their own feelings." The students reacted with disappointment, elation, and a desire to do it again, better. Observing their work in the hands of an audience gave them brand new information.

Watching the students interact with the attendees, Ceasar and I realized that the most valuable feedback will always come from a wider audience than the standard, obvious authority of teacher, boss, or client.

All for One, One for All

It's important to remember that an audience relates to the overall show. If one person's work suffers, the rest does, too.

The space we used for the exhibit was huge, bland, and institutional. The students delighted in transforming the space, and as a result, the pieces often became substantial installations in themselves. The challenge was to make it a cohesive, comprehensible show. This was not an easy task when some of the pieces included a soundtrack while others required a quiet, contemplative space, and some needed strong lighting while others wanted total darkness.

The thread I mentioned earlier—supporting your own expression as well as others'—was evident as the students began to set up the space, all the while trying to ensure that everyone's project had equal consideration. This was extremely difficult, not because the students were competitive but because they were so focused on their own work. Although it was tough to absorb at the time, this was an exercise in understanding community.

Assuming Responsibility

One year, the work on the portraits and the exhibit began simultaneously. Everyone signed up for a task that would contribute to a successful event. The work groups included Budget, Documentation, Materials,

Equipment, Space Planning, Publicity, Food/Audience, Program Coordination, Online Communication, and Technical Advice.

The students felt pressured with all the work they had to do. But within a short time their efforts were rewarded with results and personal satisfaction. They applied for a grant and received all the funding they requested, their publicity efforts drew impressive crowds, the documentation provided an after-event Web site, and so on. The success was theirs, together.

The Adrenaline of the Deadline

With the opening just hours away, students were amazed at their own resourcefulness. For example, one student replaced her original projection screen with sheets of plastic, producing layers and shadows that were totally unexpected. Another student created a "room" by framing space with Christmas lights. Life-size mannequins, annotated oranges, and cozy hangouts all materialized in bursts of creative energy.

My goal in teaching is to clear the runway so the students' work can take off. The best way I can do that is by encouraging them to take ownership of their own work and to see it in a broader context. The judgment, passion, responsibility, and commitment to one another must come from the students themselves. Faced with all of this, I've never seen them do anything short of amazing.

4

QUESTIONING THE TOOLS

We do not use technologies as much as live them . . .
men release powerful changes into the world . . . with no
attention to the ways in which these 'tools' unexpectedly
rearrange their lives.
—Langdon Winner

Your
Cell
Phone,
Your
Self

I have a colleague whose observations about human nature have always impressed me, and one recent remark really struck home. "I see people using their cell phones while they stroll along the beach or in the park," she said, "and I wonder if they cannot be alone with themselves."

Like many of you, I go for long walks to clear my head or think through a new idea. Just looking at and observing my surroundings is almost always a way to get unstuck, and I feel reassured knowing that I can benefit from my own solitude. But lately I have been bringing my cell phone with me. It seems that the more I have on my mind, the greater my tendency to call someone. As I walk and talk, I'm oblivious to what is around me; my mind's eye is with the person I've called. By the time I finish my walk (which is usually around the end of the conversation), I can't even remember what street I was on.

Back in 1996, I wrote a column titled "The Computer Is Not a Tool." I was expressing my concern that communication professionals were referring to the computer as "just a tool." In my column, I wrote, "This statement implies that we see the computer as an autonomous object that we can direct, one that we can choose to use or not use, embrace or reject. That's like saying, 'A car is just a vehicle,' and seeing a car as simply a means to get from one place to another. We know that a car is much more: it is a force that has shaped our lives, our society, our world. To see a computer as

a tool is to suggest that it exists to carry out our intentions as we choose. I believe that this is a naive attitude. We are way beyond the choice of whether or not to allow computers into every aspect of our lives, just as we are beyond choosing whether or not to make cars a part of our lives."

I was urging an awareness of how profoundly we were being affected by computers. In particular, I was concerned about the learning and working spaces that we were constructing for our students and ourselves. And I still am. We line up workstations in dark, windowless spaces. These are rooms that are arranged for computers, i.e., tools, not for people. These spaces do not encourage creativity and could be mistaken for any profession's computer lab or office.

These points are useful to ponder as cell phones become as ubiquitous as computers. At the most superficial level, a cell phone is a replacement tool, affecting the way we maintain contact with one another, just as the car is a replacement for transporting people and goods, and the computer is a replacement for analyzing and translating information from one form into another. But again, those are superficial aspects. If we look more deeply, we see that the car has changed the way we build our environments and the computer has changed the way we live and work within those environments. And now, the cell phone is changing the way we live within ourselves.

Langdon Winner, author of *Autonomous Technology*, wrote, "We do not *use* technologies as much as *live* them . . . men release powerful changes into the world with cavalier disregard for consequences; that they begin to 'use' apparatus technique and organization with no attention to the ways in which these 'tools' unexpectedly rearrange their lives."

If you're like me, your cell phone is an all-encompassing device in your daily life. It is with you at all times, filled with digital content that is both trivial and vital, from your to-do list to the details of your identity. It is your primary method of being in touch with your world. And like any tool, it affects the way you develop creative ideas. A pencil sketch on a sheet of paper has a very different life from a digital sketch that can instantaneously link to—and be altered by—a universe of people, places and things.

The cell phone's capabilities and my dependence on them are growing exponentially. The more I learn, the more excited I am about the cell phone's potential to add to my life, and the more anxious I become about what it has already taken away—like my long walks where I am alone with myself.

Twenty-Five Years of "Better"

Right after Nokia opened its flagship store in Manhattan, I went to check out the upscale space and cell phones. I was so distracted by the array of high-resolution cameras, Carl Zeiss optics, and pivoting screens that I almost missed the third floor.

A small stairway led to a dimly lit room, and a discreet sign that said, simply, Vertu. A saleswoman accompanied me to this inner sanctum, where each phone was lit by a spot and looked like a Faberge egg. My first question was: "How much do these cost?" The price tag for the most desirable phone was $86,000. Eighty-six thousand dollars for a cell phone!

I said, "It must have lots of bells and whistles." "No, not at all," she replied, and pointed out its unique craftsmanship, diamond encrusted case, and simplicity. Seeing that I was still mystified, the saleswoman announced the feature that, for me, clarified everything: a single, dedicated button that makes a direct call to a concierge almost anywhere in the world, 24 hours a day, 365 days a year.

I looked at my scruffy phone. On one hand, I have used it for years and have not yet taken advantage of all its features and services. But, on the other hand, I would have to study the manual (and the billing plans) for hours to learn how to use all those capabilities.

And thus came my epiphany: the most sophisticated device is one that combines simplicity and service.

Some of you may remember the 1987 visionary Apple film *Knowledge Navigator*. In the film, a professor opens an elegant laptop and is greeted by a window with a young man wearing a bow tie. The professor does not correspond through pull-down menus or double-clicks; he just talks. As the "butler" helps the professor with personal and professional obligations, we see that he is the ultimate secretary, able to assist in all matters of research, preparation, and hand-holding, as well as connecting instantaneously with people and data from all over the world. Its promise was a new vision of information access, communication, and user interface. Like Vertu, this was the epitome of simplicity and service.

As I left the Nokia store, I thought about the decades-old *Knowledge Navigator* vision. In many ways, we are there. We can find anything, anytime, anywhere. Like the professor with the butler, we are instantly assisted in all matters. Anyone reading this already knows it; all I have to say is Google, and you can fill in the rest.

But guess what? We actually only have half of the equation. We have service but not simplicity. In other words, the user interface still sucks. Two and a half decades ago, the concept of *wysiwyg* (what you see is what you get), plus pull-down menus, scrolling, and double-clicks was a breakthrough. But it is essentially unchanged. Whoever heard of anything in the computer world being the same after twenty-five years?

By now, this way of interacting with computers (and cell phones, DVD players, and iPods) is ingrained. For many of you reading this book, it is your native language. You grew up with it, and your fingers and thumbs know it as well as you know a spoon or a toothbrush or the millions of other things that you learned before you even knew how to read.

Way back in the early 1990s, I wrote a number of articles about user interface design. I unearthed one of these articles from a buried folder, and was amazed (and dismayed) to see that I could have written it today. Here it is, word for word, from 1994.

Ten Years of "Better"

A friend of mine recently broke her leg, and she's bored, bored, bored. I've been promising her for years that I would teach her to use a computer. I figured this would be the perfect time.

Her husband has a PC and periodically tries to teach her how to use a word processing program. Each time, they end up fighting. I have

maintained that the problem is not with either of them, but with the PC. If she had a Macintosh, she'd learn in no time.

I got my old Mac Plus out of the basement and brought it over. After thirty minutes of, "No, no! You have to select something first!" she thought staring at a wall was preferable.

Ten years ago, we were treated to the public introduction of the Macintosh user interface. It's now 1994, and the way we interact with computers is essentially the same as it was in 1984. Menus, selecting, and clicking. If I brought my friend the newest, most advanced machine available, it would not be any easier to learn and not any more intuitive than the Mac Plus. Over the past ten years, the advances in features, storage, speed, power, compactness, and portability have been phenomenal. But the advances in user interface—people working with computers—have been minimal.

Just as there was a breakthrough that released us from typed commands and gave us point-and-click, there must be another substantial leap. Can we have an "appliance" that anyone can turn on and use immediately?

Okay, I know the argument. More complexity means a more complex interface. You can't expect it to be easy. The computer is incredibly versatile; of course you have to learn its vocabulary.

Wrong. Our civilization is built on portraying complexity in simple, comprehensible, usable forms. Calendars, clocks, maps. And what about the telephone? It is the most versatile tool I can think of, and the simplest. All the truly complex work is invisible to us, going on at lightning speed in switching centers.

(Twenty-five years ago, a phone was more akin to Vertu. Now the landline phone is used as a last resort and in cases where a human is preferable to a Web site. Even so, you usually have to tolerate burdensome phone menus and bad music.)

What stands in the way of a radically different, simpler, more intuitive user interface? There are tons of obstacles. Here are a few.

First, companies are very mindful of their installed customer base. It is unwise to make radical changes to something that your customers have learned and become accustomed to. A computer user who has used a program every day and knows function keys like the back of his hand may balk at throwing that out and learning to use icons instead. The result, by the way,

is a hybrid interface where you are faced with a screen full of icons, menus, and dialog boxes requesting your preferences. Messy.

Second, there is the idea of standards. Apple dictated a consistent user interface across all software programs that run on the Macintosh. This made life easier all around. But, as I've said in other columns, the risk is that something becomes a standard prematurely. We accept a feature and everything is then built on top of it. We're stuck with it. One example is the QWERTY keyboard. The layout of the keys was deliberately designed to inhibit typing speed, to keep the old typewriter hammers from colliding with each other. Computer keyboards are QWERTY because of a standard that is now impossible to discard.

Third, it's much more profitable for companies to develop new features. More features sell more software. It's much more quantifiable than an overhaul of a user interface.

And here's what bothers me the most. We have learned the language of these computers and we have accepted it. It was hard, but we did it. And now, as we are faced with more and more complexity, we figure okay, we'll learn a little more, because we already have so much time and money invested. It only hurts a little, and we're used to it. It is a subtle form of abuse.

We hear about advances that incorporate new technology, like voice recognition. These are incremental changes that are built on top of the existing user interface. The next logical step in user-friendly computing is uttering short, militaristic commands like "Open window," and "Select folder." Ugh! It is incremental fixes that will ruin us.

The most radical suggestions often come from students. I went to a Pentagram reception recently, and one of the partners showed a student's design for a clock. A chunk of metal is on a wire that's strung above the kitchen. The chunk moves across the room. When it gets past the toaster, you know you're late for work. This design relates time to physical surroundings. This is open thinking, not incremental thinking.

When something is vastly better than its predecessor, it's pretty damn hard to put it aside completely and get a fresh look, and make a radical change. Clicking on icons and selecting from menus is a world better than typing cryptic commands. But on this tenth anniversary of the Macintosh user interface, it's time to think about making "better" better.

As I said at the beginning of this chapter, the ultimate sophistication is simplicity and service. Most of the devices that we had twenty-five years ago have advanced in service beyond our wildest imaginations, but they have become increasingly complex in usability.

If I were writing about other technologies, like the devices that we use for cooking, talking, listening to music, and watching TV, my complaints would be the same. They are more complex to use than they were twenty-five years ago.

I want my Knowledge Navigator.

Improvisation and Interfaces

This morning as I withdrew cash from my checking account, I was acutely aware of the ATM's cold and intolerant manner. There it stood, rigidly demanding that I select the amount of cash I wanted. When I didn't answer right away, it beeped at me insistently until I complied. How rude! A few hours later, I was rushing to an elevator, and saw the elevator door closing, preparing to take off without me. "Wait!" I said, and pushed the button. The door opened. How accommodating!

Every piece of technology that we use has an interface. From an electric toothbrush to a computer, the interface is the means by which you communicate with a device and the means by which it communicates with you.

An interface is also a filter. The more I observe people's relationships with technology, the more I realize that there is no such thing as a neutral interface. It affects how you express yourself and what you get back.

In 1995, I had an appointment as a research associate at Harvard University and started a group called Interface & Invention. This was a time when the field of interface design was still relatively new, and my colleagues and I wanted to find playful and creative approaches. For one of our meetings, I organized an improvisational theater session, and we worked with an experienced improv performer. Our goal was to heighten our awareness and understanding of interfaces by acting them out—by "being" an interface.

We began our evening of improvisation by listing characteristics of interactions. The list grew quickly: friendly, nasty, arrogant, sleazy, authoritative, cooperative, obsequious, sarcastic, tentative, anxious, and stupid. Next, we listed technologies with which we all interact. This list included an electric toothbrush, ATM, microwave oven, alarm clock, elevator, computer, burglar alarm, and VCR. (Remember, this was 1995.)

We then volunteered in pairs: one person to represent a technology, the other person to represent a user. Through random pairings of words and people, we performed a series of hilarious and enlightening encounters with a sleazy elevator, an arrogant ATM, an authoritative alarm clock, a cooperative electric toothbrush, an overly eager computer, and a stupid VCR.

The first improv was between an arrogant ATM and a young woman. The young woman slid her card into the machine's shirt pocket and requested thirty dollars.

"I don't think so!" replied the ATM sarcastically.

"Please, I have a date!"

"No way."

The woman pleaded and bargained. "Maybe twenty-five? Okay, how about twenty?"

After refusing repeatedly, the machine finally made it clear that the young woman had only fifteen dollars in her account. The young woman shouted, "I'll take it!," grabbed the money, and ran.

Next up was the cooperative electric toothbrush.

"How's this? Too fast? I'll slow down. I'd better get that plaque buildup over there. Oh, did that hurt? Hmmm, yes, it feels a little funny. Would you like me to set up a dentist appointment for you?"

The user nodded as the "toothbrush" wiggled her capable fingers (bristles) in front of the user's face.

Then came the overly eager computer. As the user approached, the computer said, "Hi! Want to try Excel?"

"No," said the user, "I'm in a hurry. I just need to check my e-mail."

"Oh, okay, want me to just give you the short stuff?"

"No, give me everything."

"Oh, okay. Want me to display it in the order I received it?"

"Yes, fine."

"Oh, but there's one from your boyfriend. It's really sweet. Do you want that first?"

"What?" said the user. "You read my e-mail?"

"Well, no. I mean, yes. It's from him so I thought it might be important. . . ."

"Look, just give me everything."

"Oh, okay, here . . ." The computer delivered all the e-mail, then said, "Are you sure you don't want to see Excel? It's a new version and I think you'd really like . . ."

"Shut down!"

After the improvs, we discussed what we saw and how improvisation increased our awareness of interfaces. Some insights were obvious. Others came days later, as we "interacted" with our hair dryers, toasters, alarm clocks, and so on. The arrogant ATM made the account owner increasingly obedient. We noticed that the user never questioned the machine's validity; she accepted that she had only fifteen dollars. By the time she was able to get her money, she was happy to have that much. Have you had an encounter with a machine in which you trusted the information because of the machine's authoritative nature?

The accommodating toothbrush and its user had a pleasant exchange and seemed to be working together toward the mutual goal of healthy teeth. Moments ago, I used the thesaurus in my word processing program. Now I see that one of the reasons I like this feature is because it makes suggestions in no particular order and doesn't assume that I'll comply.

The eager-beaver computer made the user increasingly impatient. It reminded me of a program that "helpfully" tidied up my desktop without telling me. As a result, I thought I'd lost an important file.

One of the most important areas of research going on today concerns "agents," programs in our computers that will help us to schedule appointments, find interesting articles, shop for groceries, record TV programs, meet compatible men or women, etc. Software programs that bring relevant information to our attention may appear as anthropomorphic characters with bow ties or simple text in the corner of the screen (or bathroom mirror or car visor). Either way, there is no question that our computers will become increasingly knowledgeable about our actions and will strive to make our lives more efficient.

Just how helpful do we want our agents to be? Do we want a dial that lets us turn down the "intrusion" volume? What if the obsequious computer decided to be so helpful that it not only read the e-mail, but also answered it?

This is not so far-fetched. We've all received automatic e-mail responses from people who are on vacation. A program with some intelligence could feasibly send out more specific responses, depending on the addressee's user profile.

After the evening of improvisation, many thoughts of the scenes reappeared. Do our tools change to accommodate us? Should they? (Do you have tools that you cherish because they have adapted to you, like a pair of hiking boots that you have broken in?)

Is it our goal to make tools efficient? Or do we want tools that encourage us to be more introspective, or perhaps to experience an event more deeply? Can you imagine a pencil that encourages you to slow down and take time to reflect on the sketches that you have just made?

During that evening, I learned that improvisation is a wonderful technique to shake off preconceptions and to increase our awareness of the ways that we use (and are used by) technology. We have a relationship with each piece of technology we use. We rarely ponder how that relationship affects our actions, our choices, or even our creative goals.

The
Quality
of
Technique

The first time I used a large-format 4 × 5 view camera, I fell in love with its beauty, its complex process, and its paraphernalia. The whole experience, from viewing the upside-down image on the glass to seeing the transparencies, was a visual feast. My next step in this adventure was to make a huge Iris print. When I saw the image on the monitor, scanned by an expert who could hold the subtlest highlight and shadow, I got another rush from the mega-dose of detail. It was not until I saw a printed proof that I stopped and really looked at the whole picture. I was shocked to find that it was, after all that work, a dud.

My initial reaction was to blame the failure on my obsession with technique. After some consideration and a cool-down period, I settled into a more balanced view: the quest for technical quality has its pros and cons. It can propel *and* restrain the quality of the work.

Common Ground

A wonderful aspect of my large-format exploration was the conversation it instigated. People love to discuss what they know. In camera stores, I have spoken to knowledgeable salespeople who shared information about lenses, film, used camera equipment, and eBay experiences. When I crossed over to the digital side of the process, the same thing happened; people were delighted to share tips about fine art papers for ink jet printers, inks and

their longevity, and Web sites, such as www.inkjetart.com, that described processes and sold supplies. I compared notes with friends about printers and scanners, exchanging files so we could test the differences.

I treasure these discussions. In addition to the encouragement they gave, each exchange contributed to my ability to make technically viable work. But at the same time, I lament the fact that the discussions were primarily about technique. When we looked at an image, it was always with a loupe or a histogram. We never discussed the concept, meaning, or relevance of the work.

The Club

The pursuit of technical quality is like a club, and it can be both democratic and elitist in its membership policies.

Exhibiting knowledge is a generous act, but it is also a way to prove, by using a tangible system of measurement, how good you are. Sometimes the strict allegiance to technical quality is a way to keep the club small and exclusive. The irony is that the people inside the gates are typically the ones who lose. A rejection of a "low quality" technique may also be a lost opportunity. If measurement becomes the focus of the quest, it can inhibit one's ability to wander into uncharted territory.

The conflict between proven quality and unknown opportunities is nothing new. Alfred Stieglitz wrote about it in 1897 in the *American Annual of Photography*. In his article, "The Hand Camera—Its Present Importance," Stieglitz discussed the popular modern camera that many serious photographers—"champions of the tripod"—considered a toy. According to Stieglitz, Kodak's slogan, "You press the button, we do the rest," fueled the professional belief that the hand camera and bad work were synonymous.

Stieglitz, however, saw the value in this "toy." Because of its "ease in mechanical working," the camera became second nature to use, "so the eyes and mind can be fully occupied with the subject." Stieglitz discussed the reaction of his colleagues when he showed them the negative for his picture *Fifth Avenue, Winter*. They advised him to "throw away such rot: 'Why, it isn't even sharp and he wants to use it for an enlargement!'" Stieglitz declared that his negatives "are all made with the express purpose of enlargement, and it is but rarely that I use more than part of the original shot." He went on to state that this camera had opened up a new area of work for photographers.

Stieglitz emphasized skills that were not technical, but instead, grounded in looking. He described patience, studying lines and lighting, and finding the moment at which everything is in balance and "satisfies your eye."

Serving the Work

In order to satisfy the eye, technique has to serve the work. In a *New York Times* article, "Chuck Close Rediscovers the Art in an Old Method," Lyle Rexer wrote about Close's revival of the daguerreotype, a photographic technique that has been out of style for 150 years. Rexer described at length the exquisite clarity of the plate and the unique, rarefied skill of daguerreotypist Jerry Spagnoli. Even in the newspaper reproduction of Close's daguerreotype self-portrait, you can see that the qualities are very similar to his paintings. As Close says, "I have always attempted to create images that deliver the maximum amount of information about the subject."

Maintaining balance requires diligent attention. Professionals and amateurs alike, in any of the arts, sometimes wander off their intended paths and get tangled in the thicket of technique, whether it's the pursuit of or rejection of technical quality. When the work is in balance, technique is neither the hero nor the enemy.

Memory
Is
Cheap

Perhaps you have heard this famous story from Plato's *Phaedrus*: The Egyptian god Theuth enthusiastically brings his new invention—writing—to King Thamus, claiming that it would make the Egyptians wiser and improve their memory. The king responds, "This discovery of yours will create forgetfulness in the learners' souls, because they will not use their memories; they will trust to the external written characters. [Your disciples] will have learned nothing; they will appear to be omniscient and will generally know nothing."

I think of this story often because it is so relevant to contemporary daily life. How many times a day do I collect, download, store, back up, copy, forward, or file a piece of information, intending to retrieve and peruse it at some later date that never seems to come? It is so easy, fast, and inexpensive to have access to whatever I want to know that I often succumb to the frenzy of acquiring information as opposed to actually learning something. When we have instant access to everything, do we actually *know* anything?

An extreme but prophetic example to ponder is the work of Gordon Bell, who has embarked on a mission to record every moment of his life. In the article "A Head for Detail" in *Fast Company*, Clive Thompson wrote: "For the past seven years, Bell has been conducting an audacious experiment in 'lifelogging'—creating a near total digital record of his experience. His custom-designed software, 'MyLifeBits,' saves everything it can get its

hands on. For every piece of email he sends and receives, every document he types, every chat session he engages in, [and] every Web page he surfs, a copy is scooped up and stashed away. 'MyLifeBits' records his telephone calls and archives every picture—up to 1,000 a day—snapped by his automatic 'SenseCam,' that device slung around his neck."

Later in his article, Thompson asks, "So, what will life be like when nothing is forgotten? Provocative as that question may be, it's hardly theoretical . . . the power of machines to create boundless memory—and to augment and even transform human thinking—is only going to become more pronounced."

Both stories—*Phaedrus* from around 370 B.C. and "A Head for Detail" from November 2006—are referring to the ways that we record and document, and how we use (or abuse) that near-infinite capacity to conduct our present-day lives. In the view of King Thamus, the "technology" of writing inhibits our ability to think and discern. But, in direct opposition, Gordon Bell says, "Using computers to remember will free our minds for more creative thinking."

The debate gets more interesting when you consider it in the context of your own art making. For example, replace the general questions above with more specific questions in the realm of photography. Do the tools of digital photography strengthen or weaken our ability to produce creative, insightful, meaningful images? We all know the facts: compared to just a few years ago, we can shoot much more recklessly. Concerns about storage, lighting conditions, and miscellaneous imperfections are greatly reduced because we have ample capacity and ability to manipulate images later.

So, do we take advantage of being able to capture it all at top speed so that afterwards, when we have time to reflect and consider the context, we can be more discerning? By being able to shoot indiscriminately, we are collecting more now so that we can make choices later. We can look with hindsight and see more clearly. We can make interpretations.

Or is it better to do our thinking in the present moment, when all possibilities are open? (This brings to mind the title of the International Center of Photography exhibit of Hungarian photographer Martin Munkacsi: "Think While You Shoot!") One might argue that we have a higher quality of creative juice when we are immersed in the physicality of the scene itself.

Regardless of whether you think it is better to rely on yourself or to rely on external devices, here is another concern: our materials may not be eternally available. When we create artwork in the electronic realm, our material is ephemeral. It lasts only as long as the software that can access it or the media on which it can be played. Even though your final product may be physical, the iterations will most likely remain in electronic form. Will they be stored on CDs and stuck in an old shoebox, never to be read again because you no longer have a device that can read one? I just threw out a stack of 5½-inch floppy disks because they were useless.

We are not in danger of losing *old* physical artifacts. Our society saves historical buildings, furniture, crafts, clothing, books, magazines, and posters. Instead, we are losing *new* artifacts. The contents of today's DVDs, Web pages, and text messages will become inaccessible.

In addition, electronic media are highly susceptible to the "automatic flush." Physical material sticks around until you decide to throw it out. But bits disappear unless you make a conscious effort to save them. Some of my e-mail accounts, for example, automatically delete mail after a specified time. Consider how you create artwork in the digital realm. Unless you repeatedly decide to save progressive iterations individually, you automatically destroy them. On the Web, visually groundbreaking sites are changing at a frenetic pace, and as they are updated, the old versions disappear from public view.

The past keeps getting closer because it is stored on media that is becoming more temporary, more short-lived. The preservation of interactive material requires translating (and re-translating) onto hardware and software that can display all of the features. Perhaps we will soon have a more graceful way for our data to evolve. But for now, lots of evidence of creative explorations will not be accessible in the future. And we will have lost valuable insights about the past.

Do new inventions make us wiser, or do these tools weaken our powers of thought and understanding? Is technology an aid or a hindrance to our ability to be creative, insightful human beings? The dilemma is an ancient one, and we ask the same questions anew with every century.

The
Future
of
History

History is not truth. It is a constantly evolving rendition of the past—malleable and elastic, perpetually in rewrite.

By definition, history is the branch of knowledge that records and analyzes past events. It is documented from a particular point of view; the historian makes subjective choices of what to include or exclude, even if the goal is neutrality. There are always new interpretations or revelatory unearthings of neglected evidence.

Our contemporary society has the ability to save infinite amounts of data. It seems that everywhere I look, wherever I am, something is being recorded and stored: contact information for online shopping; frequent flyer mileage in an airline's database, video footage on a subway's security system, a friend's dog trick on YouTube, an MRI at a doctor's office. This abundance of data is being generated, collected, saved, stored, and dispersed by people of different ages, countries, religions, races, sexual orientations, body types, IQs, and socioeconomic classes.

This makes me wonder how this 24/7 recording will affect the way future generations see the past. Will this diversity of sources promote a more "democratic" view of history? Do we get closer to the truth by having more from which to select?

We have grown up with a backdrop of institutions that hold the artifacts of our collective and individual histories. The structures containing

these pieces are massive, impressively imposing record-keepers (think the National Archives in Washington, D.C.; the San Diego Museum of Man; the New York Public Library; etc.). They represent centuries of accumulation, during which time the techniques and technology of collecting have been constantly evolving—from a hand-written letter wrapped in tissue paper to a digital video that is automatically downloaded.

Contemporary practices of recording and storing are not only more automatic and far-reaching, they are also aided by changes in personal technology. All of us, with our built-in GPS tracking, shareable calendars, digital pedometers, and digital heart rate monitors, are consciously and unconsciously becoming major contributors to the national tonnage of historical data. We are storing the mundane, repetitious data of our everyday lives. How much do I weigh today? How many steps did I walk? How does that compare to a week ago? A year ago? And that is just individual record keeping, saved in a more or less personal space. In a more distributed realm, our daily purchases—the books we buy, the music we download—are recorded and can be viewed by various networked "friends." Teens on Twitter share minute-by-minute details of buying a pair of boots, breaking up with a boyfriend or girlfriend, or brushing their teeth.

And therein lies the goldmine for the historian. It is not the momentous aberrations that reveal the accurate story; it is the repetition of the trivial details of life. There is richness in the mundane. What do we choose repeatedly? Where do we go repeatedly? What do we take pictures of repeatedly? When we see what recurs on a daily basis, we find out what is lasting, what is real. By seeing what repeats, we discover the essence, something closer to "truth." Why? Because the accumulation and volume of repetition allows us (and historians) to see patterns that can tell us more about who we are as a society. This could, in the future, reveal a more accurate view of a population's past.

Finding patterns is one way to comprehend disparate information, to make complex data more understandable. We look for rhythms, consistencies, and similarities. Patterns allow us to make comparisons and predictions. By pulling piles of data apart and reassembling them into like-minded groupings, we can see basic tendencies, develop theories, and arrive at conclusions.

But there is also the danger of forcing patterns. If you try to create a comprehensive view of all data by identifying the common denominators,

and in the process, you banish all the unruly elements, then you defeat the goal of presenting an accurate picture.

How will future historians deal with this abundant and wildly diverse data? Will they develop equally varied theories and analyses? Will they discover more meaning? Or will this profusion become so overwhelming that the only way to make sense of it will be to make it quantifiable, assembling stories with statistics and logic instead of soul?

In the future, will history be more true or more false?

5

THE MEDIUM CONTROLS THE MESSAGE

"Data Voice & Image: How Media & Technology enhances, inhibits, promotes, filters, interprets, modifies, recreates, kills, allows, enables, predicts, reflects, determines, requires, encourages Expression."
—Course title, Harvard Graduate School of Education

Shaping
Content

More and more, adults, adolescents, and children make their intentions known and understood through media in both public and private environments. Content—the stories that people want and need to communicate—is affected enormously by the medium through which it is told. Marshall McLuhan, the philosopher and communications theorist who is most famous for his phrase, "The medium is the message," wrote, "Societies have always been shaped more by the nature of the media by which men communicate than by the content of the communication." The more that people understand the ways in which media shapes content, the greater their ability to express their stories. This was the main idea behind the course that Ceasar McDowell and I developed at Harvard Graduate School of Education.

Our original course title was "Data Voice & Image: How Media & Technology enhances, inhibits, promotes, filters, interprets, modifies, recreates, kills, allows, enables, predicts, reflects, determines, requires, encourages Expression." Later, we just referred to it as "Data Voice & Image" (the long version would never have made it in the school catalogue), but the course was about all these words and many more. Our goal was threefold: to see the ways that different media shape content; to increase our awareness of our own preconceptions about different media; and to explore ways of using media and technology to maintain the integrity of content. We did this

through class exercises and assignments that forced us to see ourselves on both sides of the camera, so to speak. We are authors as well as viewers; we watch and we are watched.

In the first class of the semester, the students participated in an exercise that was indicative of the rest of the term. Ceasar and I began by asking for several volunteers for four separate groups. Privately, we gave each group the same task: each person was asked to describe his or her very first memory. The members of group one stood up and told the stories of their memories to the class. Next, group two was told to go off to another room, where they told their stories to a video camera that was transmitting a live feed to the classroom. The members of group three related their stories on a telephone down the hall, and the class listened on speakerphone. Finally, the members of group four typed their stories on a computer, and their keystrokes appeared in real time on a large projection screen in front of the class.

After the stories were told, we discussed what we had seen and heard, focusing on our preconceptions about each medium and the ways it affected the stories. We noticed, for example, our disappointment in the video quality; we were accustomed to high production value, and seeing a straightforward, poorly lit, static headshot was annoying. We did, however, watch with interest and empathy. (Little did we know then that years later, YouTube and reality television would increase our tolerance for bad video quality but lower our ability to watch for more than a minute.) The speakerphone, on the other hand, heightened the visual aspect of the story; as we listened to the voices, we all had rich, vivid pictures in our minds, especially when the storyteller provided details. Next, we discussed watching the words form letter by letter as they were typed on the screen, and we agreed that it was like watching private thoughts: words would appear and then get deleted as the storyteller reconsidered what to express.

These comments came from the viewer side of the medium, i.e., the watching, listening, or reading side. Another layer of understanding emerged when the students discussed how it felt to have their own stories watched, listened to, or read. "I was nervous about the way I looked on video." "I was concerned about typing too slowly or too much." "I thought I was being taped so I held back." " I wasn't sure if anyone was listening, and I felt funny without any feedback." There were positive comments as well: "I can express myself better in writing, so I enjoyed typing my story." "I like

the telephone. It reminds me of staying in touch with friends, so that was very comfortable for me."

As I mentioned, one of our goals in this course was to explore ways to use media and technology to maintain the integrity of content. In other words, it is important to know that before all the filtering begins, there is an intention, a story that someone wants to tell, and specific content to be delivered. We see this more clearly when it is our own intention that we are trying to convey.

Whatever our stories may be, we have an ever-changing array of media through which to tell them, and a growing number of circumstances to use those media in school, in our work, or at home. As soon as the story leaves our lips or our fingertips, it is filtered. The better we understand and use those filters, the greater our ability to express ourselves.

Concentrating on Context

In his multimedia projects "Judy's Bedroom" and "Scottie's Bedroom," David Reed inserts his own paintings, through video and set creations, into the rooms in Alfred Hitchcock's film *Vertigo*. I'm particularly intrigued by Reed's description of his ambition to become a "bedroom painter." He explains, "Then my paintings can be seen in reverie, where our most private narratives are created."

As artists, when we create a piece of work, we typically hope that it will move out of our studios and into other places: a gallery, a book, a Web site, someone's home, and so on. Like Reed, many artists are specific about the context in which they want their art to live, and that affects their creative decisions. For others, the very randomness of an unknown context, where the piece will take on unexpected meanings, is an exciting prospect.

In either case, it's important to understand that your artwork does not exist in a vacuum. You know that you can't control what experience a viewer brings from his own life. By the same token, you can't control the layers of meaning that are imposed by the environment that surrounds your work. This is especially true if your work is reproduced and exists in multiple forms, which is more likely now than at any other time in history. Each iteration moves a little farther away from you and a little bit deeper into a new context, and therefore, a new meaning.

Remember the Eames' film, *Powers of Ten*? As the camera zooms out,

you can see that every individual structure exists within a bigger landscape. Every context is a container, which is in turn contained by another. Think of an advertisement on a printed page, showing, say, shampoo. The shampoo ad is within the context of a magazine. That magazine is displayed next to others on a magazine rack. That rack is surrounded by other products in a store, and that store sits next to other buildings in a neighborhood. The perception of that shampoo is constantly changing; each context introduces an exponential expansion in variables and affects the way the audience perceives the content.

When you look at a painting by Titian in the nave of a church, with stained glass windows, prayer candles, and parishioners kneeling in the pews, it's quite unlike viewing a Titian in a museum, where it is surrounded by informative wall texts, strolling visitors, a café, and a gift shop. Go a step further and imagine the Titian on a postcard that you take away, removing it to yet another container. When I see a painting reproduced on an umbrella, I think about how far it has traveled from its original form. Bertolt Brecht said of art that has been reproduced and transformed into a commodity: "It will no longer stir any memory of the thing it once designated."

Walter Benjamin, in his classic 1936 essay, "The Work of Art in the Age of Mechanical Reproduction," explored the idea that the advent of reproduction—particularly photography and film—will forever change the way people perceive an "original." In this era, it's a given that our work will be reproduced. What's more, it's likely that the reproductions will themselves be reproduced and then placed in yet another context or medium. Often, as Brecht said, they will bear little resemblance to their original meaning. One obvious example of this phenomenon is music sampling. The early, award-winning hip-hop group De La Soul took pieces of music as disparate as those of Liberace and the Drifters and placed them side by side, creating an entirely new experience. Stock photos are another example of reproductions that end up in unpredictable places, often conveying totally different messages with each appearance.

Even something so subtle as the passage of time can literally change a meaning. Present-day communication is so rapid that the speed of delivery affects the perception of content. As recipients, we expect content on the Internet to be Now, a magazine to be Then, and a book to be History. We perceive the content differently for each form based on the time that lapses from its origin to its delivery.

Context provides the environment—both physical and mental—that holds and inevitably filters content. For artists, context is like breathing: we're constantly engaged with it, but we rarely focus on it. Each element we make is affected and surrounded by other elements that we did not create. In a world of transmissions, transformations, and reproductions, an artwork's content is perpetually under the influence of its context. Every change in context can cause a change in perception and meaning. Context may be subtle, sometimes even invisible, but it is never neutral.

Framing
Video

The first time I was called for jury duty, I was not impaneled, but I did get to see the seventeen-minute video explaining the jury process. The program is carefully scripted and cast, with very good sound and picture quality. The judge, who serves as our onscreen host, tells us that the video we are about to see is not a Hollywood movie; it is real life.

During a coffee break, I went to the main floor of the courthouse and watched a bank of about ten black-and-white video monitors, each with an image that changed every second. The images were from surveillance cameras set up throughout the building: in hallways, corners of rooms, and the parking garage. Each image held an element of tension: Was I about to see something bad happen? After all, surveillance cameras are primarily there to look out for criminal acts. As a friend once perceptively commented, on a surveillance camera, everyone looks guilty.

As I looked at the monitors I thought back to the introduction video. The judge said that the video he showed us was real life. Nah. Those grainy, black-and-white surveillance images, now *that's* real life.

We're accustomed to many levels of video, from high-definition TV to YouTube to cell phone-recorded clips. We know that video is a powerful medium, capable of influencing, convincing, and even dictating.

More and more, video is becoming the basis by which people learn and then determine what is the "truth." We are trained to look critically at

video and to question its veracity. But do we question how video portrays the truth about each of us? Increasingly, we are represented more by video than by physical presence. Think about how often your video image is already being captured (without your awareness) in banks, grocery stores, toll booths, apartment buildings, restaurants, and so on. Add to this the likelihood that you will have more and more conversations, classes, meetings, and transactions in which you will participate via video.

Naturally, you want your video image to represent you truthfully (whatever you believe the truth to be). Is one form of video more "real" than another? And how often will you actually have a choice?

Years ago, I explored video reality in an exercise with my students. We watched a segment from the television series *Eyes on the Prize*, an intense documentary that included historical black-and-white, grainy footage, as well as more contemporary sharp color footage. Afterwards, we discussed which type of video came across as more believable than the other.

During our discussion, one student shot color video (with a high-end Ikegami camera) of the other students as they commented. He zoomed in on each individual as she spoke. The students were aware of the camera, and knew when it was aimed in their direction. However, they did *not* know that there was also a hidden surveillance camera. It was situated so that it taped the entire class from a high viewpoint.

Later, they watched in surprise as side-by-side monitors displayed both videos of their discussion: the high quality color footage and the black-and-white, grainy surveillance footage. After the initial shock of being taped by a surveillance camera, the students jumped back into a discussion, only this time *they* were the subject matter. Which footage was "real"? Which footage portrayed the true version of the class: the clear, unconcealed video, or the blurry, clandestine surveillance?

The obvious answer was the surveillance footage, in which the students were unaware of the camera. But as most advertisers know, it's not so simple. The obvious form of truth is easily appropriated. Over the years, video has been like a chameleon, literally changing its colors in an effort to be viewed as "real." Because we no longer trust anything too slick, we have been given a whole genre of television ads, news, and reality television shows that use low production value and appear (or at least pretend) to be unscripted and unedited. Low quality equals high authenticity.

As in the class exercise, it's eye-opening to see how you personally are represented by video. Yes, you can be aware of the ways you are influenced and sometimes manipulated by what you see on video. But when you are *in* the video, you come one step closer to feeling its power to portray a given version of the truth.

Imagine what it might be like to be represented *only* by video to prove, for example, guilt or innocence, or to arbitrate a disagreement. The video's role is to show the truth. How would you choose to represent yourself (assuming, that is, that you have the choice)?

At the end of my jury duty, I passed the bank of monitors on my way out of the courthouse, and I caught a frame of a suspicious-looking person walking too quickly out of the building. Later, I realized it was probably me.

These Pictures Are Meant to be Sent

A few years ago, I was with a friend in an art museum where signs explicitly stated: "No photographs." My friend may not have planned on taking pictures in the first place, but he had just bought a new phone with improved camera resolution. How could he resist? In a move that looked like he was checking his messages, he took a shot, e-mailed it to a buddy in California, and then put his phone back in his shirt pocket, clearly enjoying his undercover prank.

Cell phone owners are shooting and e-mailing photographs in evolving and unpredictable ways. Already, these visual communication devices are influencing the pictures we take and the pictures we see, impacting our lives as both consumers and artists.

Consider these factors. The cell phone is both a communications device and a visual recording device. It is light and tiny; it's as portable—and indispensable—as your wallet, and is therefore always with you. By pressing a few buttons, you can transmit, i.e., publish, your image or video to anyone or any group on the planet who has access to the Internet. The image is transmitted within a few seconds. The image can be accompanied by a simultaneous text or voice message.

These individual features of phones are not so radical; each capability can be accomplished with some other device. Instead, it is the *combination*

of features—the functions, size, portability, speed, ease of use, and ubiquitous nature—that creates the recipe for change.

Surreptitious Picture Taking

Picture taking has been prohibited for years in all sorts of places, for all sorts of reasons: privacy, copyright infringement, legal issues, and safety. Soon after 9/11, when this country was at a particularly high level of paranoia, the quest for banning reached new extremes. For example, New York City Transit proposed a ban on unauthorized photography in the city's subways and buses. What was once innocent tourist snapping had now become a suspicious, potentially terrorist activity. (The proposal, which was opposed by photography, press, civil rights, and free speech groups, was ultimately rejected.)

With a phone's camera, one can easily take a picture without anybody noticing, and transmit the image instantaneously. This prompted cell phone bans by institutions that are addressing not-so-innocent surreptitious activities. Health clubs throughout the United States prohibit phones in locker rooms. Technology companies that are fearful of industrial espionage take measures to curtail cell phone usage. In Japan, where phone image quality is superior, some bookstore visitors were sneaking pictures of magazine pages in a form of stealing called "digital shoplifting." Celebrities' guests bring their phones to parties and instantly publish pictures to the public. The list goes on and on.

The Incidental Photojournalist

An important turning point in the history of journalism was the 1991 amateur videotaping of the police beating of Rodney King. This video was taken because a bystander just happened to have a video camera and was at the right (and horrific) place at the right time. (A portion of his footage was shown by news reports around the world. The rest is history.)

The highest priority of the news media is speed; the winner is the one who can bring the story to the public the most quickly. In recent years we have seen numerous examples of video and pictures being taken by "real" people who have sent their photos and footage to media outlets. Especially in the case of accidents, crimes, and terrorist activities, photojournalists cannot always be on the scene because no one knows where "the scene" will be next.

The cell phone camera combines the two most important aspects of breaking news: having someone on the scene as the drama is unfolding, and being able to get that imagery immediately to the widest possible audience.

Think of this from the networks' point of view. To be competitive, they must have real time access to pictures from every newsworthy event. Often, this access is in the form of video screen grabs from another news agency (for example, in the early days of the war in Iraq, Al-Jazeera, the Qatar-based news network), and there is a fee for the footage.

But what happens when a picture comes cost-free from the guy on the street with a cell phone? Television networks have been asking for content from viewers. Does this reduce their expenditures for news? Will images have copyright protection? What does this mean for the professional photojournalist?

Changing the Nature of the Conversation: Pictures as Part of Decisions and Iterations

Pictures have become an integral part of a phone conversation. They are often a natural part of making decisions. Combining a picture with a text message encourages iterative picture taking, that is, a sequence of pictures to lead up to a decision.

Let's say you're in a store, choosing a pair of glasses, and you want to show your spouse the possible selections. With your cell phone, she can see the various frames that you're trying on—front, profile, or a closer view of the detailing. It's easy, cheap, and fast. Do you like this one or that one? Watch this. Now, watch that. Which was better? And so, decisions will be made (or arguments prolonged).

In this sense, the pictures are not meant as keepsakes. They are meant to illustrate, to add information to a conversation. They zoom by like words, with no intention of being saved. The camera's role has changed. It is not an image-keeping device. Instead, it is a real time extension of the sender's (and viewer's) eye, just as the traditional phone is an extension of the voice. So we can say to each other, "Look at this with me," wherever and whenever we want.

The Art of Cell Phone Photography

But what about pictures as art? To consider a cell phone as an actual camera—something worthy of taking a picture that would appear, say, in a photography exhibition—may at first seem improbable. But fine art is not

about technical features; just look at the beautiful pictures taken with a Holga. Besides, like digital cameras, the cameras in phones are increasing in resolution and, at the time of this writing, are typically in the three to five megapixel range, with models that already exceed eight megapixels.

I am most curious about how cell phone cameras will affect the pictures that people choose to take. Does the fact that you can instantly transmit and publish a picture change what you want to take a picture of? One friend asked this important question: "Would cell phone cameras be so appealing if you couldn't broadcast the pictures to others? How much of their popularity is tied to the popularity of photo blogs?" Think about all the sites where you can submit cell phone pictures and videos. Sending pictures to, for example, Flickr, guarantees a big audience. Granted, there are probably as many photographers being shown as there are viewers looking. But the pictures are likely to be seen by many people, and perhaps this gives the photographer an added sense of motivation and validity.

An early exhibition of cell phone pictures as art was shown in Rx Gallery in San Francisco. The "Mobile Phone Photo Show" captured and processed thousands of mobile phone photographs sent in by participants from forty-one different countries. According to Kurt Bigenho, a co-curator of the show, "The emphasis was on immediacy (the database automatically delivered new images as soon as they were submitted), a de-emphasis on the cult of the artist (anyone could register, anyone could submit), and an exploration of a new type of art project, one composed of multiple small contributions from a large population of contributors."

When I asked Kurt about the ways in which an image shot with a cell phone differs from one shot with a normal camera, he pointed out people's urge to communicate their excitement in exploring the visual world, especially with street signs and found street graphics. "The impression I have is that participants are out exploring the city and finding interesting evidence of communication, and then in turn communicating these findings. Finding and sharing. [This is an] exploration of place and a found aesthetic [think *Found* magazine]. There's a cast-off, 'I may never see this image again,' quality."

As we adopt (and adapt to) this ever-changing technology, the cell phone camera's playful quality will be overshadowed by the integral place it assumes in our lives. Its entrenchment will change the way that all of us—as individuals, consumers, and artists—communicate, which will in turn change the way we know the world.

Learning (Again) from Las Vegas

I've always felt that the field of architecture is worth watching because, like contemporary art, it is a barometer of our time. So, after a weekend trip to Las Vegas, I decided to read the classic book *Learning from Las Vegas* by Robert Venturi, Denise Scott Brown, and Steven Izenour. When it first came out almost forty years ago, *Learning from Las Vegas* caused a big ruckus in the architectural world. In the early 1970s, modernism was the prevailing force; form, as opposed to content, was all-important. For example, think Robert Ryman: a pure, white painting is about surface. Period. The book used Las Vegas as a way to attack the modernist stronghold, claiming that the city—primarily the Strip—held lessons that could help to define a new way of thinking about urban architecture.

The Las Vegas Strip was a creation of the automobile age, during which speed and mobility had become major factors in people's lives. The Strip's roadside signs (huge, elaborate, and in-your-face) rather than the buildings (low, modest, and set back) were the prevailing architecture. These signs were an architecture of bold communication and the opposite of modernist buildings where, as the authors pointed out, the signs were so diminutive that they contained only the most necessary messages, like "Ladies."

One lesson in the book stood out as particularly prescient. The Strip shows that "people, even architects, have fun with architecture that reminds

them of something else, perhaps of harems or the Wild West." What lessons does the *new* Las Vegas hold?

The current genre of architecture on the Las Vegas Strip is the pop-up book city. When you stand next to the Statue of Liberty at the New York New York Hotel-Casino and look through its Brooklyn Bridge, you can see the Eiffel Tower at the Paris Las Vegas. Just up the street, there's the Venetian Hotel's Rialto Bridge and the tower of San Marco. The buildings have taken over the job of the signs. In fact, they *are* the signs; their facades are three-dimensional billboards. They go one step further than reminding us of something else; they are replicas, surprisingly accurate replicas, of something else. They are stories, an architecture of narrative, the *Reader's Digest* version of cities. You "read" the buildings based on your lifetime consumption of mass media; the mini-cities juxtapose the icons that you have come to know through travel books, newspapers, television, movies, and the Internet. Those icons are the same ones that you see behind the newscaster's head.

But the real lessons here are not suggestions for a new kind of architecture. Instead, we have an opportunity for a fresh reading of the barometer. What can this architectural exaggeration tell us about the times in which we live? The authors of *Learning from Las Vegas* suggested that we see the Strip not as a prototype but as an archetype—an exaggerated example from which to derive lessons from the typical. The exaggeration today is in the form of communication, or more specifically, visual "sound" bites. We are no longer speeding by in a car. Instead, we are stationary and the information is speeding by us. And our appetite for fast information has become truly gluttonous. Therefore, an architecture of communication must be denser, more compact, and able to tell the story in a single bite. In addition to relying on our collective mass media experience (Eiffel Tower = Paris), the Strip's builders have created cities-at-a-glance. One city fits neatly within your peripheral vision or, more importantly, within the viewfinder of a snapshot camera.

Most of what we know about the world is received through transmissions. Current communication technology gives us accuracy, immediacy, and clarity, but it also encourages super-sophisticated editing, framing, cropping, etc. On one hand, transmissions are representative of the truth, like the Strip's replica cities. On the other hand, they are illusion and artifice, also like the Strip.

Learning from Las Vegas was written as a book of questions, a rally to use an exaggerated place as the basis for ongoing study. Las Vegas is a city where physical changes keep pace with communications, and as such, it continues to offer relevant inquiry. For example, when we look at the daily news, do we rely on the familiar compilations in lieu of seeking the original story? Is faster, i.e., up-to-the-minute, learning better than slower, i.e., deeper, learning? Have icons become more real than reality?

Trust
Me,
Trust
Me
Not

When I was a kid, there was a story in the *Boston Globe* about an airplane crash. The newspaper reported the "facts" about the accident. My father, who was a pilot, read the article and told me, "This account is full of misinformation. The reporter doesn't know his subject."

Then my dad taught me something I have never forgotten. He said, "The only reason I recognize that the story is incorrect is because I know about flying. Does this mean that other stories I read, where I don't know the subject matter, could be just as misguided?"

The lesson was simple: misinformation—whether it is intentional, innocent, or incompetent—can come from anywhere, even the officially sanctioned "reliable" sources.

We all have our own awakening moment regarding the need for skepticism. Sometimes it is the result of a personal experience, like a botched medical report or bad financial advice, or it comes from a public cover-up, such as Watergate or the missing Weapons of Mass Destruction. We are a discerning population, and our skepticism is a healthy instigator of self-education. We demand to know the truth. Paradoxically, the more we know, the less we trust the sources from which the "truth" comes.

This is nothing new. But now we have an infinite number of sources, and as we discover more hidden truths, it is inevitable that we become increasingly wary of the information we receive. A phrase like "the most trusted

name in news" immediately invites cynicism. So, how are we, as a skeptical populace, dealing with this simultaneous increase in sources and decrease in trust? What happens when the word "trust" itself must be questioned?

As artists, we are hypersensitive to the word truth, especially when we look inward at ourselves and our work. As makers of fiction, we purposely alter the facts to communicate a deeper authenticity. But where do we go to get those facts?

Untrustworthy and Proud of It

Like most of you, I rely on numerous sources for information, whether it is something as trivial as a weather report or as weighty as a doctor's diagnosis. It is significant that so many of us question the authority of, for example, a doctor, and that we have so many resources with which to question that authority. But it is even more important to take note of whom we are turning to for this supplemental (and sometimes contradictory) information. We are beginning to look to sources that admit that they are vulnerable to misinformation, because they question themselves and take measures to self-test.

Which leads to this irony. We are placing our trust in the sources that are willing to say, "Don't trust me."

One of the most extreme examples is the online encyclopedia Wikipedia, whose slogan is: "The free encyclopedia that anyone can edit." At one point, the Web site said,

"Wikipedia's [ten] million articles have been written collaboratively by volunteers around the world, and almost all of its articles can be edited by anyone who can access the Wikipedia Web site. . . . This openness encourages inclusion of a tremendous amount of content. About 75,000 editors—from expert scholars to casual readers—regularly edit Wikipedia."

By contrast, the *Encyclopaedia Britannica* advertises itself as trustworthy based largely on its expert contributors: "More than [ninety] have won Nobel prizes. Most are authors, university professors, commentators, museum curators, scientists, and other experts chosen for their field expertise."

I applaud the participation that Wikipedia has spawned and I believe that it supplies valuable material. But it also really scares me. Here's why. Most of us go straight to the Web to get information for three reasons: it's free, it's instant, and it's accessible. So, we supplement our visits to the doctor or

lawyer or newspaper with visits to the Internet. That sounds good. But read the description of Wikipedia again. What they are basically saying is that it's free, open, and has tons of content. But what about accuracy? Abundance can be a double-edged sword.

We are, hopefully, discerning, but it's not easy to be thorough. I was unnerved when a friend said that she did not know that Wikipedia was open to anyone's editing. And why would she? When you Google and get a Wikipedia hit, you don't necessarily see its motto. This is not Wikipedia's fault. It just underscores the point that all information is suspect.

Trust My Watchdog

Organizations that are much more established are also displaying their potential for inaccuracies and their methodology for engaging the public. For example, newspapers, radio stations, and television stations appoint individuals called ombudsmen. "Inside a news organization," wrote NPR's first ombudsman, Jeffrey A. Dvorkin, "an ombudsman is there to get answers for listeners, viewers, and readers. News ombudsmen (also known in newspapers as public editors or readers' representatives) investigate complaints and concerns about matters of accuracy, fairness, balance, and good taste. The concept has been spreading in U.S. and overseas media, especially over the last few years."

Again, this is not new. (Dvorkin said that news ombudsmanship has been around since the 1920s.) But e-mail and blogs have resulted in—or caused—a greater demand for self-examination from these organizations. That, along with the ease of e-mailing, has dramatically increased the correspondence that the ombudsman receives. The public engages in critiques of every sort, including vehement disagreements with the ombudsman himself.

This certainly sounds healthy, but I pity the poor ombudsman. The organization has one person who is tasked with answering a growing and clearly overwhelming number of queries (and rants). This makes it an impractical model. On the Web, many-to-one does not work; one-to-many or many-to-many does. In that respect, Wikipedia is a more appropriate model for the Internet. Still, appropriateness does not replace trust.

Individuals as Independent Sources

With the Internet, it is easy to seek advice or information from independent individuals through bulletin boards, chat rooms, blogs, and

so on. It's not that we are rejecting the corporation (though you have to admit, the word does leave a bad taste—even "Corporation for Public Broadcasting" starts to sound like an oxymoron). But we are supplementing those authoritative sources by trusting individuals who may not have any credentials. Where we used to look only to sanctioned professionals, now we consider everything.

At first glance, this seems crazy. Why would you trust an unknown and unaffiliated person? Probably because you recognize a need or an experience similar to your own. For example, when my technically savvy colleagues search the Web for the answer to a software problem, they usually find the solution from an independent bulletin board or blog. Even if the bulletin board is hosted by the software company, the answer typically comes from an independent programmer who has struggled with the same question. My colleagues trust the individual's experience because they trust their own. Likewise, if I need advice about letterpress or digital printing, I am confident that I can judge whether an individual's advice is trustworthy.

In other words, the more we know, the more we are able to trust those who do not have official credentials.

What Does Trust Look Like?

We have always known that photographs are not representations of truth. It is impossible to take a photograph that does not have some form of editing imposed, even if it is simply what one happens to leave out of the frame.

That said, there are innumerable ways to purposely make a picture lie. Anyone who has even the slightest knowledge of photography is aware of this and knows that whatever appears in a newspaper or on television or on a Web site is not necessarily the truth. In the past few years, our images of the world have come from increasingly varied sources. In the chapter "These Pictures are Meant to be Sent," I write about the growing number of non-professionals who are sending their photos and video footage to media outlets.

As I mention in that chapter, a seminal point in our media history was the public distribution of the Rodney King video. The important points are that the footage was shot by a person who had no affiliation with a news organization and that it was clearly taken with a consumer (low quality) video camera. It was, therefore, deemed real.

124

Does it follow that we trust something more because it *looks* like it was photographed by an amateur? Occasionally there is an image on the front page of a newspaper that is shot by an unaffiliated (uncredited) individual. The photo is impressive not because of its beauty or professionalism, but for the opposite reason: its power is in its graininess and the fact that it was clearly "grabbed." In the chapter "Your Video Self," I write about the way advertising agencies often manipulate video so that it looks less slick and more "real."

But even that is changing. As we all know, the division between amateur and professional imagery is eroding. The equipment used by professionals is now often the same as the equipment used by amateurs, just as the means of distribution, i.e., the Internet, is the same. It is no longer clear which images come from the independent individual and which from the professional organization.

In addition, the amateur photos and videos that would have appeared on CNN or in the *New York Times* are showing up on outlets that are alternative or independent instead—even, for example, a student "reporting" from a desk in a dorm room. Often, these individual productions are created on a regular basis and gain their own loyal following. I may not trust the content delivered by these independent "newscasters," but that does not mean that I have blind faith in the established press. On the contrary, the individual blogs often act as truth cops for the more official outlets.

Where Do You Sit?

As I said in the beginning of this chapter, misinformation—whether it is intentional, innocent, or incompetent—can come from anywhere, even the officially sanctioned, "reliable" sources. So, whom do you trust more? Professional or amateur? Individual or corporation? Accredited or self-taught? Network news or YouTube?

These are particularly tricky questions for you, the readers of this book, who are visually sophisticated. You know much more than the general public about the ways in which content is shaped. You know how it is edited, arranged, and manipulated before it reaches its audience.

Even as I write these words, I have to acknowledge that I, too, am a member of traditionally authoritative publishing venues. I have to face this question myself. Do you, the reader, trust me more because I write for established publications, or do you trust me less?

6

ANOTHER KIND OF LANGUAGE

Often, when you want to understand something, you have to take it apart of apply another kind of language to it. Drawing is another kind of language.
—Richard Serra

Another
Kind
of
Language

I really shouldn't be writing this essay. I should be singing it. Or drawing it. Or dancing it.

When I attended an exhibit called *Drawing is Another Kind of Language* at the Sackler Museum in Cambridge, I enjoyed seeing the collection, but the most powerful aspect for me was the *idea* of the exhibit. The words of the title came from the artist Richard Serra: "Often, when you want to understand something, you have to take it apart or apply another kind of language to it. Drawing is another kind of language."

At the time, I was teaching at Harvard Graduate School of Education; my students were extremely articulate and comfortable with the spoken and written word. This was their primary means of expression as well as learning. One of the goals in our class was to explore the expressive power of different media by comparing print, photography, video, sound, multimedia, and so on. We did not have required readings or papers; we had "doings." Our assignments were designed to achieve a deeper understanding of each medium, by, as Serra said, applying a different kind of language. For example, one project was to compose and perform music using the medium of print. There was one restriction: do not use standard musical notation. The results were wonderful, and sometimes very John Cage–like. One group re-enacted a library setting and developed a symphony of page turning, book dropping, date stamping, newspaper ripping, and paper crumpling. The students had

previously thought of print in terms of content; now they were aware of its weight, sound, texture, age, value, and fragility; in a word, its form.

A six-part PBS series titled *Yo-Yo Ma Inspired by Bach* is one of the best examples I have ever seen of this concept, that is, of applying another kind of language in order to deepen one's understanding. Yo-Yo Ma has been playing the Bach Cello Suites since he was four years old, and the suites have always been an important part of his life. He invited artists from other disciplines (figure skaters, a choreographer, a filmmaker, an artist/architect, a landscape designer, and a kabuki actor) to collaborate with him and interpret the Bach suites in their own mediums. Yes, he wanted to share this lifelong source of inspiration with others. But there was something more: he could deepen his own understanding of something he dearly loves by not only seeing it, but also *performing* it through the eyes of another medium.

Each episode was enormously inspiring, but for me, one stands above the others: his collaboration with the choreographer Mark Morris. In an early conversation, we see Yo-Yo Ma and Mark Morris discussing the process they are about to begin. Ma wants to know if he can understand the choreography and actually be influenced by the action on the stage. In other words, could the way that he knows and plays this music be changed by his being part of this new action, by his playing in concert, so to speak, with Morris' choreography? Morris grins and answers, "Well, that's the point. I think it's a good idea."

The next scene shows Ma playing for the dancers as they rehearse. Ma watches and begins to smile. He is looking intently, clearly responding to their movement. He comments later about their effect on his playing, how he plays by using the dancers as his music. As I watched Ma play and the dancers perform the full piece, I not only heard Yo-Yo Ma's music differently, I began to *see* it. I saw the music as a layered structure, as a narration, as a conversation. I began to understand the music through the language of dance.

Towards the end of the episode Ma and Morris continue their discussions, but the words they exchange are minimal; the real communication and meaning are carried by gestures and music. What began as a somewhat stiff but respectful exchange of spoken language evolved into a friendship that shows, mostly through body language, their warmth, humor and delight.

The written word is our most respected form of communication. It is the one we judge and are judged by. It's the way we explain ourselves

to the broadest audience. But sometimes words can hinder understanding. Mark Rothko once said that the reason he didn't give titles to his mature paintings was because he was afraid that words would paralyze the viewer's imagination.

I have just thrown approximately eight hundred words at you to explain the importance of another kind of language, but I feel comfortable knowing that countless sounds, sights and movements surround this page. They will tell you things that will make you understand my words more deeply.

The
Power
of
Language

We're pretty agile with language. We play with it, try new phrases and throw out old ones, and allow our vocabulary to change according to our needs and interests. But do we realize the profound influence that language has on the way we think and the way we create? The vernacular of different cultures, genders, age groups, and professions says more, so to speak, than we sometimes realize.

As participants in an increasingly technology-driven society, we often take on and adapt to new language with each other, with our tools, and even within ourselves. There are pros and cons. In the chapter "Another Kind of Language," I describe ways in which language can be mind-expanding, giving us ways to articulate concepts that were previously unimaginable. But language can also be restrictive, excluding expressions of emotion or culture. When we adopt a new language, we may find that we lose the essence of what we are trying to say in the first place.

An example of this dilemma is described in the article "Sex and Death in the Rational World of Defense Intellectuals" by Carol Cohn. Cohn was a college teacher attending a summer workshop in nuclear weapons, nuclear strategic doctrine, and arms control, taught by "defense intellectuals."

After the workshop ended, Cohn continued her studies for a year. "I found myself aghast," Cohn says, "but morbidly fascinated—not by the nuclear weaponry, or by the images of nuclear destruction, but by the

extraordinary abstraction and removal from reality that characterized the professional discourse.

"I had long believed that one of the most important functions of an expert language is exclusion—the denial of a voice to those outside the professional community. What I found was that no matter how well-informed or complex my questions were, if I spoke English rather than expert jargon, the men responded to me as though I were ignorant, simpleminded, or both."

In order to be heard, she adapted her everyday speech to the vocabulary of strategic analysis. "I spoke of 'escalation dominance' and 'preemptive strikes.' I found, however, that the better I got at engaging in this discourse, the more impossible it became for me to express my own ideas, my own values. . . . the word 'peace' is not part of this discourse. As close as one can come is 'strategic stability.'" To speak the word peace "is to brand oneself as a soft-headed activist instead of an expert."

And here is her most chilling realization. "As I learned to speak, my perspective changed. I had not only learned to speak the language; I had started to think in it. Its questions became my questions, its concepts shaped my responses to new ideas."

As I read Cohn's observations, I thought about how easily this happens. When you enter another profession's world, where its members hold the positions of power, you must be the one to accommodate their language in order to be heard. And it's natural to want to solve the problems at hand, to use your intellect, to show your ability. I remembered my own first experience working with computers. Though it's inconsequential when compared to developing nuclear weaponry, the circumstances are parallel.

In the late 1970s, I was at MIT working on a project to create typefaces for interactive video books. Back then, it was useful to speak in the language of bits and bandwidth. I began thinking in digits, judging the value of my work in terms of numbers. For example, we were proud of techniques that made smaller characters legible, thus allowing more characters in a line. We proudly bragged about getting seventy characters across the screen, with as many lines of text as possible (and, of course, no leading). The individual characters looked good, but the text was a nightmare to read. I suddenly realized how foolish we were to substitute a false, quantitative goal for the real, qualitative goal of legibility.

However, I also learned a language that opened a new way of thinking. I learned that each pixel is represented by a numerical assignment, and

that the number can be endlessly and effortlessly changed. I now had access to guilt-free experimentation. I understood the concept of "what if."

Not long ago, a colleague of mine was making a video of movement and poetry that required sophisticated programming, and she worked closely with a programmer at MIT. Jolie described the effects she was looking for by using her own language. She said to Doug, "I want the words to fade in and out, to appear like blue buoy lights at night: not quite a blink, but leaving an impression, almost like a sound that lingers."

She could have said, "I want a two-second dissolve at five-second intervals." Instead, she conveyed a feeling, using senses and memories. Doug translated the feeling into his language, and together they made sure that the original intention was achieved or that they discovered something new. They preserved their respective languages, and they communicated.

Language is our primary way of expressing our ideas and our emotions. Being conversant in a new language certainly opens doors, but it's often a struggle to maintain your own voice once you've passed through those doors. And if you lose your original artistic goals and vision, what's the point?

The Forward Momentum of Failure

At the far corner of the stage, a figure walked through deep water, laboring against a powerful current. At least that's the way I saw it. In reality, the dancer was four feet above the floor, stepping slow motion into the cupped hands of her partners. Like the rest of the performance by Snappy Dance Theater, this dance was graceful, dark, funny, and totally absorbing.

Viewing other art forms is a way to gain a deeper understanding of your own work: it simultaneously gives you distance and insight. As I watched the dancers, their movements provoked all sorts of ideas, from conceptual themes to visual shapes. The next day I sent fan e-mail to Martha Mason, Snappy Dance Theater's artistic director, and after some correspondence she suggested that I come to a rehearsal.

I attended, in rapid succession, four rehearsals. Martha was choreographing a new commissioned work, and during the course of my visits, the pieces progressed from general notions to exacting, specific movements. Choreographing a dance is a visible articulation of the creative process, full of analogies for the visual arts.

Recording Your Progress

Snappy Dance Theater's rehearsal tools are minimal; the dancers record their progress with their bodies. At the beginning of a session, they

collectively recall their most recent iteration of a movement, and then they are ready to proceed. As they clarify a sequence, it becomes part of their bodies' vocabulary. They are not precious about stages of progress; they know that their bodies will recall the best moves. They retain the essential.

As I admired their streamlined process, I thought about my new computer. I love the speed with which I can record my own creative iterations, and the massive capacity for storing everything from sounds to movies. But when I record every stage in fear of losing inspiration, or because I am unsure which is the best version, then I am using the tool as an aid to postponement rather than forward momentum. I'm creating variation baggage. My best work occurs when I trust the essential and move on.

Sustaining Risk

I've always subscribed to the belief that risk is a necessity in the creative process, but I never really contemplated what that meant. Thanks to a particularly risky Snappy invention, a picture began to coalesce.

A big chunk of one rehearsal was devoted to perfecting the three-body wheel. Each dancer holds another's ankles. At any time, one dancer is in the air, about to dive forward, face first, towards the floor. Their banter increases the adrenaline. "It's so scary, like flying, my face going forward. . . . You're pushing my face into the ground. . . . Let's try it backwards. . . . I almost ate your big toe!"

Martha asks, "Is it too scary for performance? Will we freeze up on stage?" But they keep going, almost ignoring the question. The excitement builds as it begins to work, and words are replaced by exhilarated laughter. Then, as soon as it's clear that they can conquer it, they move on to the next piece of choreography.

What is the analogy of risk in the visual arts? The obvious answer has to do with shock, but that's too superficial. Risk, I believe, is a place between unsure and sure, where you are in unknown territory, you can't see what's around the corner, and yet you continue, full speed ahead. What's more, you keep it up. Robert Rauschenberg said it well: "I usually work in a direction until I know how to do it, then I stop. At the time that I am bored or understand—I use those words interchangeably—another appetite has formed." Rauschenberg is not just confronting uncertainty, he is *sustaining* uncertainty.

The Momentum of Failure

In order to achieve graceful, perfectly syncopated moves for a performance, Snappy Dance Theater has spent countless hours engaged in flaws, clunkiness, and failure. We all know how important mistakes are in the creative process. Picasso said, "My pictures are often made by a sum of destructions."

We typically perceive failure as a painful struggle. But as I watched the dancers, each failed move was greeted with something more akin to joy. Instead of considering an attempt as wrong, it was clearly one step closer to right.

How refreshing it would be to look forward to failure! Imagine using it as momentum to propel your work further. It's not easy, but lately, when I feel the weight of a bad morning's work, I picture one of the Snappy dancers, sweaty and determined, saying, "I've almost got it."

When we are fortunate enough to be engaged in the creative process, we're like dancers: immersed in an activity where all of the ingredients—including progress, risk and failure—contribute to a forward momentum.

Promoting
Visual
Thinking

Why doesn't America value art? I ask myself this question often, and the answers I come up with are the obvious ones. Works of art have no productive function in our economy. Art is self-indulgent. Contemporary art is too difficult to understand. Most people prefer to watch sports.

I asked the owner of my favorite café, because he's Italian. Rather than commenting on America's culture, he pointed to my notebook and said, "In Italy, school children have notebooks with grids. In America, you have notebooks with lines." In other words, we are taught to think in a linear manner, while they are taught to think spatially.

A person's life is defined—I would even say determined—by socially constructed systems and beliefs. Ironically, the systems are so much our foundation that they become, like the foundation of a building, invisible. Before one can question a system, one must be aware that it exists. Lined notebooks hardly seem like a system that needs challenging. But to me, they are symbolic of the way our society thinks and what it values.

We are a verbal culture; words and numbers are the basis of our communication.

You may say, "Wrong! Look at our news, entertainment, and advertising. Our knowledge about the world comes to us more through pictures than words." I agree that, *as an audience*, we are a visual society. But our language for analyzing, responding, describing, judging, and communicating

is verbal. Visual thinking is always translated into verbal language in order to be widely understood. Words are our lingua franca, our common tongue. They are the way we communicate across our disciplinary boundaries.

As children we are encouraged to draw, but within the first few years of school, visual activities are replaced by exercises with words and numbers. I'm not arguing against an education of verbal literacy; these skills are crucial for success in any field. Instead, my concern is that visual thinking gets left behind. And because of that, our society suffers.

In her insightful book, *Notebooks of the Mind: Explorations of Thinking*, Vera John-Steiner describes the value of visual thinking. She begins by pointing out that verbal language is a highly ordered and conventionalized form of expression. In contrast, no corresponding visual language exists. And here's the line that caught my attention: "The absence of a single visual language may assist in the discovery process." Images that rush through our heads are difficult to externalize, and John-Steiner suggests that this very difficulty allows for more play and exploration. Words and numbers are rigid and specific. Conversely, there are many diverse forms in which creative individuals shape and convey their "inner visual notions."

Her book has many examples of famous thinkers whose visual imagery was integral to their process of discovery, including Einstein. She writes: "Evidence of a lifelong pattern of using visual and kinesthetic pictures was found among Einstein's papers at Princeton; among these was a description of a 'thought experiment' he conducted at age sixteen. After Einstein read Maxwell's theorem which proposed to explain light waves, 'he imagined himself riding through space, so to speak, astride a light wave and looking back at the wave next to him.'"

I don't think our society denies the value of visual thinking. But I believe that there is a severe lack of awareness and a paucity of support, respect, and encouragement for it. As a result, our visual thinking is underdeveloped. At the same time, our verbal language—and our structured way of thinking—is becoming more entrenched.

The devices and venues that deliver news and entertainment are very visual. However, as I said earlier, the way that people exchange ideas, instructions, and information is primarily verbal, whether it's face-to-face, phone or keyboard. A huge chunk of our daily communication consists of e-mail and text messages. This kind of communication is typically direct, linear, and concise.

One of the reasons that America does not value art is that we are so ignorant about visual thinking and its many languages. The problem is self-perpetuating because visual thinking is an intangible process that we can't measure or categorize. It does not fit neatly into our system of words and numbers. The very nature of the verbal language keeps us within its boundaries.

As a society, we don't spend much time nurturing our visual thinking. Watching TV doesn't count. It's impossible to be fluent in a language or a way of thinking if you don't practice it. You can't understand something unless you are involved with it, rather than being just a silent audience.

I know that I am preaching to the choir. But if we want to convince others that visual fluency is valuable to our society, we need to be able to articulate that belief. And for that, we need to be fluent in verbal *and* visual languages.

Video
as
Learning
Art

I taught a multimedia workshop in Germany, and six months later I received a surprise videotape from some of the participants. They had shot lots of tape during the two-day session and later edited it into a mini documentary. The videotape showed the attendees in action: brainstorming, listening, creating, and showing one another the results of their work. I was delighted and grateful; I found it enormously helpful to review the event, and to see what worked well and what didn't. It was a wonderful vehicle for reflection, not only for those who made the videotape, but also for the other participants.

This reflection, however, took place quite a while after the event. The workshop was about sixteen hours altogether, and the video piece that the members created was less than sixteen minutes. I shudder to think of how much time it took them to go through so many hours of tape, selecting and juxtaposing. The work-to-reflection ratio seemed way too high.

How many times have you shot video of a creative event—say, a workshop or a brainstorming session—and never looked at it again? I was lucky to have participants who took the time and initiative to create a short, high-content review. But what if, rather than shooting sixteen hours of tape, they had only shot a total of sixteen minutes? What if all of their editing had been in-camera, and we were able to watch it together at the end of the workshop, instead of months later, separately?

Set aside for a moment your knowledge about what it takes to make a good, well-constructed video. Instead, think of in-camera editing as note-taking. If you are writing a full-fledged article for publication, you might record and transcribe the entire event, then use it as material to be edited later. But if you're taking notes for yourself and the other participants, you are jotting down the highlights, the important points. You are editing the event in real time. A "note-taking" video is an evaluation tool for the participants.

When I was teaching at Harvard University, I was privileged to witness this technique firsthand as I watched an expert, Nobuyuki Ueda, a visiting professor of educational technology from Kobe, Japan. Throughout his stay at Harvard, Nobuyuki shared his innovative theories and practices about learning, most of which employed visual exercises. One of his most revealing activities is his use of in-camera editing. Nobuyuki refers to in-camera editing as "learning art," that is, a creative activity that helps you to understand what you are witnessing.

Nobuyuki uses this practice in two ways. First, he feels it forces him to understand the event or activity as he is shooting. He is looking for the essence, for the visual clues that give insight about the event. Second, he and his students and colleagues view the tape immediately after the activity, using it as a critiquing tool for analysis and reflection. While the event is fresh, the video provides feedback and encourages group discussion.

Nobuyuki showed us examples of his "learning art" from events he had shot in Japan, as well as pieces he made from our classes at Harvard. They were comprised of short bits that told surprisingly cohesive stories. There was no dialogue, but there were interesting uses of type: relevant words from a blackboard, screen shots of Web sites, headings from handouts, and close-ups of students' notes. He captured the different pulse points of the activities in a sort of visual shorthand, concentrating on facial expressions, body language, and interactions between people.

Although I'm a believer in this "learning art," I've also discovered that you have to choose your role: participant or observer. Near the end of his stay in Cambridge, there was a student event that Nobuyuki attended. He brought his camera and was shooting, but he warned me that it would not be like his others. This was an event in which he was a full participant, not an observer. As I watched the video later, I realized that it was, indeed, different from his other videos. It didn't feel as concentrated or focused. The few times I have tried in-camera editing, I've found that it takes complete

attention, and I could only be an observer of the event, not a participant. In each activity, someone must choose and own that role.

While you may not give workshops or teach, you are probably involved in activities—work that involves other people's participation—that you want to review and discuss. The point of using video in this context is for reflection. Where were people engaged? Bored? Annoyed? Excited? Where was the action? Where was the energy? Where was the most focused concentration? In the opportunities I've had to experience this reflection technique, I have always learned something that I would have missed, whether I'm in front of the camera or behind it.

Why
Do
You
Draw?

My goddaughter is an artist. I followed her progress, starting when she was very young and watching as her skill increased each year. Familiar things around the house—an antique chair, an array of plants, a leather couch—were represented more and more accurately in her sketches.

But what really impressed me when I watched her draw was her immersion. She sat for hours, looking and drawing, looking and redrawing, sometimes working her pencil and eraser so thoroughly that the paper gave way.

Drawing—especially perceptual drawing where one is using the physical world as the model—is unlike so many of the typical hyperactivities in our modern lives. It is contemplative, deliberate, and measured. John Berger, in *Ways of Seeing*, says that to look is an act of choice, and that what we see is brought within our reach. The act of drawing brings what we see even closer.

Drawing is a foundation. When a student begins a program in the visual arts, some sort of observational drawing is almost always on the list. In this way, drawing is often thought of as a means to an end. Many of you who are reading this book know intimately that drawing, in and of itself, is a powerful language. To consider it only as preparation and training for

other disciplines is like studying Latin solely as a way to improve verbal test scores.

I was speaking about this with Monique Johannet, an artist in Massachusetts who has been making works on paper for decades. This is how she describes her practice of drawing.

"When I was drawing one hundred percent from landscape—out every day for hours, looking at the landscape and drawing—I could physically experience space with my eyes. I remember the first time this happened. I was looking into the woods, and it was as though my eye had arms that could completely go around the tree and feel the space in back of it and around it. This only happened if I was drawing every day for hours. If I stopped, that quality would go away. It was like acquiring another sense."

Monique continued to speak about the physicality of the medium itself. Consider the paper: "its shape, thickness, texture, the color of white with charcoal, its horizontality and verticality, the placement of the image, the intensity of line. How deep do you go in response to what you're looking at *and* in response to the paper?"

Monique's words made me even more curious about this process, so I began asking colleagues, students, and readers, "Why do you draw?" Here are their answers, with my thoughts interspersed.

A Physical Act

"It's such a profoundly human activity. It's primary. It's a physical activity. A handmade medium requires touching things. It's the link between eye and hand."

As with Monique, the subject of physicality came up repeatedly as I corresponded with people who are devoted to the practice of drawing. There is a physical connection and a deep satisfaction from feeling the direct contact with the medium.

Drawing Is Meditation

Many of the artists with whom I corresponded share a common experience: when they draw, they enter a kind of meditation. Drawing provides the perfect conditions for a meditative space. Because so much concentration is involved, extraneous thoughts slide by, without taking hold.

145

"When you're self-judging, you're not meditating. There's a constant critique in your head. My self-examination is learning how to keep that voice turned off. If I'm in a meditative state, the voice is quieted. Leave the voice out. Then you can do what you feel."

"I draw because it's the only thing that naturally comes out of me. . . . It's the only thing that I don't think about. When I do think about drawing, it's terrible and forced."

In his classic book, *Flow: the Psychology of Optimal Experience,* Mihaly Csikszentmihalyi describes flow as "a state of concentration so focused that it amounts to absolute absorption in an activity. People become so involved in what they are doing that the activity becomes spontaneous, almost automatic; they stop being aware of themselves as separate from the actions they are performing."

Drawing to Think

While many artists referred to this immersive, non-thinking state, others described drawing as a way to enhance or document thinking. Drawing requires a unique commitment of time and concentration.

"Drawing became my problem-solving process. My sketchbooks are a record of my thoughts, my array of projects and ideas and poems and plans, my characters and observations and stories."

In the wonderful book *Between Artists*, Chuck Close interviews Vija Celmins about her drawing practice. She says, "I see drawing as thinking, as evidence of thinking, as evidence of going from one place to another."

On the surface, it appears that some artists draw to escape thinking while others draw to enter thinking. But perhaps these approaches are not contradictory; instead, they identify other ways of thinking. In general, thinking is considered to be a verbal activity, but one of the definitions of "to think" in the *American Heritage Dictionary* is: "To visualize, imagine." When we draw, thinking is a visual progression. Instead of forming a linear sequence of words and sentences, the "thought process" in drawing is the formation of marks that relate to one another spatially. As one artist said, "I draw because I can look at things in terms of value, lines, and texture, and forget their meaning."

"Between everything and nothing, between empty formula and chaos, between language and a meaningless babble of random noise, I approach this act of drawing."

"After college, I spent a couple months in Japan and I drew daily. I couldn't speak the language aside from being polite. Given the fact that my Japanese was horrendous, I felt very isolated. I began drawing to help pass long periods of the day that were becoming increasingly lonely. My drawings became better and better."

A Conversation That Does Not Include You

In many ways, drawing is about deep conversation—between eye and hand, between tool and surface, between perception and reality, even among the marks themselves. This aspect of visual thinking is about allowing the drawing to progress in response to itself.

The painter Philip Guston said that there is a point in his process when he must "leave the room." In other words, the conversation is taking place within the work, between one mark and another, and between the mark-making and the surface. The book *Eleventh Draft*, edited by Frank Conroy, addresses the same process for writers. In his chapter, "Not Knowing," Fred G. Leebron says that while working on his novel, he followed the characters. He didn't care what they did as long as they were the ones doing it. The characters tell the author what they will do. The conversation is propelled by the life in the work. The author (or artist) is there to carry it out.

"When I draw, I see the lines looking back at me. Even when I leave a drawing undone, it's still alive, waiting to be completed."

"There is the joy of the pencil mark that looks like it happened of its own energy."

Because I Can

Along with this sense of being separate from the work, there is a simultaneous feeling of personal accomplishment. The desire to draw often comes from the knowledge that one has a particular ability or has achieved a certain level of skill.

The first two artists' e-mails I received began with the exact same words: *"I draw because I can."*

Many expressed the same idea:

"The thrill when the sketching stops and the drawing begins, when trying gives over to experience.... The joy of getting the measuring right that occurs only in the eye."

"It is very gratifying to really nail something and be able to represent the essence of three dimensions using only two."

"Drawing was the first time ever in my life I felt a sense of accomplishment. The feeling of taking a blank sheet of paper and recreating something on it by my own hand was indescribable."

Drawing as Observation

Whether you are drawing from reality or imagination, observation is crucial. In order to represent a person, a place or an idea, or to translate it into a new physical form, you have to have some understanding of it. And in order to understand it, you have to observe it.

Several artists described their appreciation of the slow and measured observation necessary in drawing.

The artist who spent those months in Japan wrote the following.

"Drawing really allows you to absorb your subject and experience it. My photographs from my trip are great to share with people, but my drawings have an added layer of emotion, appreciation, and time that are a huge part of my trip and ultimately my maturity while there."

Sometimes we draw to understand a physical object or space. And sometimes we draw to understand something more elusive.

"Why draw: To extend the power of touch. To touch something unreachable except by eye—the ridge in the distance, the vertical cliff. To feel something in one's own body as if the object being drawn sends itself in reverse through the artist's pencil, up the arm to one's heart. Then to look at the drawing years later and remember the touch."

Mixing
Centuries

My first digital camera was a Canon 10D. I purchased it along with the necessary paraphernalia, including a lens, battery, memory card, and camera bag. When the salesperson showed me the bill, I took a moment to recover, and then joked, "Well, it was either this or a Holga." He said, "I'll be right back," went into the supplies area, and reappeared with a brand new Holga (value $35). "A gift," he said. We both laughed.

His gesture was meant to be funny, but it actually made sense. At that time, my image-taking equipment included that digital SLR, a thirty-year-old 35mm Pentax, the Holga, an occasional rental of a large-format 4 × 5 view camera, a twelve-year-old Sony camcorder, and my six-month-old cell phone. Each had its appropriateness in terms of subject matter, mobility, features and context.

A few years ago, I took this assortment of choices a step further, employing and then mixing technologies from different centuries. I had an itch to revisit mediums that I learned in art school, specifically intaglio printing. I missed the physicality of this early technology, both in the process and the final product.

Around the same time, I had become addicted to shooting fifteen-second minimalist cell phone videos, emphasizing the starkness and graininess they produce. (This is not unlike the MacVision digitizer of the mid 1980s, which resulted in a similar low-tech roughness.) Using QuickTime

and Photoshop, I made numerous six-frame sequences that looked like low-resolution Muybridge stills. I decided I wanted to translate these grainy frames to photo etchings.

I loved the idea that I could marry technologies from the fifteenth century with those of the twenty-first. But I knew that the only way I would carry out this work was at a residency. Artist residencies are great for immersing yourself—especially because they are away from home—in a project for an extended period of time. In this case, a residency was additionally compelling because of the need for equipment. I had everything I required for the digital side of the work, but I needed a completely different kind of facility for the etchings.

After extensive research, I applied to Women's Studio Workshop (WSW). It offered the perfect combination of facilities, location (remote, but two hours away from New York City), and length of time (one month).

When I got the acceptance from WSW, my first reaction was joy, immediately followed by anxiety. How was I going to get myself up to speed in etching (which I had not done for two decades) to actually produce finished work, let alone anything of professional quality? I had less than four months before my residency was to begin.

I collected and read how-to guides and attended an intensive, two-weekend photo-etching workshop. I learned what I could expect to accomplish at my residency and what I could not. But more importantly, I learned what I wanted, and it boiled down to this: I wanted to create work of quality, and I also wanted to explore the effects of marrying high-speed technology with a slower, more reflective process.

I decided to prepare for my residency in three ways: First, determine what I knew I could accomplish, given my expertise in the twenty-first-century side of the equation. Next, find the resources to produce the fifteenth-century components. Then, allow myself to leave the rest, i.e., "the marriage," to serendipity, experimentation, and the help of WSW.

I developed a process to make my cell phone video imagery. Briefly, here are the steps: shoot a fifteen-second video, translate the video to QuickTime, choose the frames that I like, and transfer those to Photoshop. In Photoshop, convert the frames to grayscale and edit for the best gray values that will produce the minimal look I am seeking. Create strips of the individual frames and produce a PDF. Finally, transmit the PDF to Boxcar

Press in Syracuse, New York, where they will produce a negative with a mezzotint screen and, from that negative, a photopolymer etching plate.

I could handle all of that using my cell phone, my laptop, and a range of software, all of which I could bring with me. So, in terms of twenty-first-century equipment, all I needed from WSW was a printer for proofing and a high-speed Internet connection. I didn't even need a landline phone; my video-taking cell phone could double as (guess what!) a telephone so I could confer with outside service providers.

I got my first taste of change-of-pace when I realized that I had to bike to the nearest hill to get cell phone coverage. Regarding a high-speed connection and printer, I was welcome to use the computer room, but only during non-office hours. They were clearly able to deal with my telecommunication needs, but it would not be the "anytime, anyplace" situation that I had taken for granted in my normal life.

Most of us in the arts are interested as much in the process of working as we are in our final product. My desire to immerse myself in centuries-old techniques was very much about the pace and the environment of working. When I arrived at WSW, I knew I was in luck. Picture this: a hundred-year-old building (formerly a general store) in a rural town. Each floor is full of equipment for different processes, including letterpress printing, handset type, etching, silkscreen, paper-making, photography, and ceramics. Down the dirt road is the Art Farm, where artists can harvest materials for making paper. The building also houses the offices, a kitchen, and my wonderful garret: a light-filled apartment on the top floor.

Luckily, my cell phone can record without coverage, so I was able to shoot anywhere: in the building, the nearby woods and fields, the town center. People quickly got used to seeing me holding what looked like a Geiger counter, as if I were measuring levels of radiation. Thus began a cycle of mixing centuries: shooting and downloading videos, transmitting files, inking plates, and printing.

My best videos, and the ones that ultimately became my final edition of prints, were shot during two day trips, one to Dia:Beacon and the other to several Chelsea galleries in Manhattan where I shot surreptitious footage of gallery-goers. Each trip was another microcosm of juxtaposition, going from a rural mercantile building in Rosendale to the vast acreage of minimalist sculptures at Dia, and then to the noisy, frenetic streets of New York. I loved

the contrast, and it added to my already heightened level of inspiration. This was what I wanted: exciting contradictions.

Each day offered up more of these contrasts. While I was editing video frames in my garret, a book-making resident was setting type by hand in the letterpress room, and another etching resident was placing old pieces of hardware in pans of water to make rust monotypes. Upstairs, the interns were working on a new WSW Web site, or in the paper-making studio, helping an artist shred an old wedding dress that she bought on eBay to make pulp.

Since my residency at WSW, I have become more aware of the ways in which artists mix centuries. Because such a wide range of knowledge is required, it's typical to see people working together and sharing diverse experience as well as equipment. Art schools are allowing disciplines to morph, encouraging students to combine pieces fabricated in the woodworking shop, the darkroom, the welding studio, and the computer lab, all the time trading obscure solutions or just the right tools.

Many established artists spend time at facilities that specialize in the techniques they want to investigate. A good example is Magnolia Editions, a fine art print studio in Oakland, California, that has combined antique and contemporary techniques in a unique endeavor called the Magnolia Tapestry Project. Working with artists including Chuck Close, Bruce Conner, April Gornik, Doug Hall, Alex Katz, Jeff Sanders, and Nancy Spero, to name a few, they use an electronic Jacquard loom to create beautiful woven interpretations of the artists' paintings, photographs, drawings, and sculpture.

When I think about all the techniques that artists study and cherish, I'm inspired by the possibilities that the past continues to offer. What better way to keep art history alive than to explore the juxtaposition of contemporary and historic mediums, and then create something entirely new?

Beyond
Description

Ann Hamilton's exhibition *Kaph* at the Contemporary Arts Museum in Houston occupied the museum's various spaces with a series of sensory experiences, from the smell of bourbon leaking through the walls to the rhythmic squeaking of a twelve-foot-long steel trapeze. *Kaph*—which means the palm of one's hand—remains clear in my mind as one of Hamilton's most moving site-specific installations.

But I never saw the exhibit. My memory is based solely on the catalogue: a modest, thirty-two-page, saddle-stitched, five-by-seven-inch booklet.

Music, visual art, architecture, and performing arts typically have supplementary items whose purpose is, quite simply, to serve a specific piece of work. But as I reflect on my secondhand experience of Hamilton's exhibit, I'm struck by the many roles that the accompanying material can have.

The text of *Kaph*'s catalogue, written by the show's curator, Lynn Herbert, goes way beyond describing and clarifying the exhibition. Along with thirteen footnote references to interviews and readings, Herbert delves into the subject of "the subconscious, that complex and unmarked territory that is the provocative province of dreams." Through her descriptions of Hamilton's work, Herbert enlarges our understanding not only of the artist's intentions, but also of the personal, interior places she compels us to visit.

For me, truly excellent material not only elucidates the work, it also *uses* the work to convey a premise about such topics as history, culture, and human nature. It goes beyond the art and the artist, and it becomes a piece of importance in and of itself. The reader is given a deeper understanding not only of the artwork, but also of the broader issues that the artist has introduced.

Let's take it a step further. Sometimes the accompanying material may actually have a greater impact than the original work that it is documenting. It may be more widely seen or distributed. It might even be more historically significant and influential.

This idea has been widely discussed in reference to architectural photography. A photograph can be more than a representative image of a particular piece of architecture; it can inform our notion of an entire era. Famous architectural photographs have come to represent a time in history, a mode of living, even a philosophy. In the August 1990 issue of *Progressive Architecture*, Thomas Fisher wrote, "We think of architecture in this century having been primarily influenced by such technologies as steel, concrete, and glass. But the technology of photography may end up having the greatest impact of all, if not on the form of buildings, at least on how we view them, and therefore, how we think about them. One could even argue that modern and postmodern architecture, for all of their differences, succeeded in part because of their memorable imagery, powerfully conveyed on the printed page. What we think of as architectural has become what we see as photogenic."

Two photographers who have had a huge impact not only on the public's awareness of modern architecture but also on the design of architecture itself, are Ezra Stoller and Julius Shulman.

Stoller's iconic photographs document modernist buildings such as Eero Saarinen's TWA terminal at John F. Kennedy Airport, Frank Lloyd Wright's Guggenheim Museum, and Mies van der Rohe and Philip Johnson's Seagram Building. Stoller became so famous that many architects didn't feel a building was complete until it had been "Stollerized." The former *New York Times* architecture critic Paul Goldberger wrote about Stoller, "His pictures are surely among the most reproduced, and they have in and of themselves played a major role in shaping the public's perception of what modern architecture is all about."

I'll bet you can picture in your head, for example, the famous

nighttime photograph taken by Shulman in 1960 of a modern house by architect Pierre Koenig. The house overlooks a grid of lights of Los Angeles, and two women are sitting in a living room that protrudes (scarily) over a canyon. The photo is titled *Case Study House #22*.

The J. Paul Getty Museum's Web site describes Shulman's photography as follows: "Shulman's widely published images marketed the West Coast's casual residential elegance to the world. Decades after the initial prints were created, Shulman's scenes continue to herald the beauty and livability of modern architecture and the glamour of the California dream."

Often, the photographs outlive the buildings. According to an *artnet* magazine review by Hunter Drohojowska-Philp, "Shulman's eight-by-ten-inch black-and-white photographs document masterpiece after masterpiece of architectural innovation by Richard Neutra, John Lautner, Rudolph Schindler, and so forth. These were among the most daring innovations in residential and commercial architecture in America yet many of them no longer exist. . . . One of the most poignant images depicts a 1947 house designed by Neutra for the director Joseph von Sternberg in what was then the rural countryside of Northridge. A condominium complex replaced the Neutra house in 1971."

The work of art, performance, or architecture can be the instigator for another artistic creation that exists independently from the original piece. The new piece is based on the original work, but has a life of its own. The viewer can have a powerful and enlightening experience from this new work, independent of the original work. One creative entity inspires another.

A field in which one art form often serves as the inspiration for another is film and video documentaries, especially those that present the artist's process. Initially, they serve the purpose of understanding the artist's works more deeply. For me, a documentary achieves its further level of importance for two reasons: first, because it places the artist in a social and historical context, and second, because it helps us to comprehend our own creative fears, triumphs, and commitment (or lack thereof).

After I saw the film *Maya Lin: A Strong Clear Vision*, I stayed in the theater and wept. Of course you would assume that I was moved by the scenes of fingers moving over the names carved in the Vietnam Veterans Memorial, representing the thousands who died in the war. But that was not what caused my welling up. I was moved by the artist herself—by her commitment, not only to the integrity of the memorial that she envisioned,

but also to the work that followed. The film documented Maya Lin's growth as an artist, describing her intense immersion in the research, design, and production processes. The film adds to the understanding of Lin's Vietnam Memorial by describing the vehement opposition she faced during its development and her ability to resist the repeated attempts to defeat her. Because of the film, I am much more aware of why that monument is so meaningful to me: it is about the fight that Lin fought, as a child of immigrants, as a woman, and as an artist.

At one point in the Academy Award–winning film, which was directed by Freida Lee Mock, Maya Lin says, "An artist struggles to retain the integrity of a work so that it remains a strong, clear vision." The film goes on to show the artist's continued creativity and growing maturity. I have since seen a number of Lin's public works, and during each visit I am reminded of the moving experience I had in the movie theater, learning about the power of integrity and commitment.

Many of you are the creators of guides, videos, books, illustrations and other materials that explain or document visual art, architecture, and performing arts. You may feel that your job is specifically to serve the work. As Ezra Stoller said, "A building is a statement by an architect. My photographs aim to express that statement, and my job was to clarify them." Or your service to that work may take you into a new realm, creating a substantial piece of work that exists on its own, perhaps one that surpasses the breadth or notoriety of the artist that inspired you in the first place. Whatever your place on that spectrum, you contribute your own talents to create an entity that serves as more than a simple description and has a lasting influence of its own.

Sound
Seeing

Every now and then I need to get a new perspective on the way I see. Over the years, I've learned to expand my visual awareness by exploring different disciplines. For example, when I work with a dancer, I see how stillness is as essential as movement. When I work with a playwright, I see how pictures are formed in the mind's eye.

So, I decided to take a course at the Museum of Modern Art in New York called "Soundwalk Studio: Making Environmental Sound Art." I was attracted by this line in the course description: "By focusing on the soundscape in which we are immersed, we can find new appreciation of our surroundings and discover a palette of material from which to create art."

As I read this, I thought, "If I looked at my environment through sound, how would it change the way I see?"

Frankly, I had no idea what I meant by that, other than that I wanted to shake up my visual language. I told the teacher, Spencer Kiser, my intention, and that I would be using a video camera as my recording device because I wanted to pay attention to sound and let the image surprise me later.

As in most schooling, what we learn during the time in class is most valuable for what it opens up to us outside of class. A small reference can be a spark that grows into a full investigation. For me, it was a quote by John Cage from *The Future of Music: Credo* that Spencer read to us the first

evening: "Wherever we are, what we hear is mostly noise. When we ignore it, it disturbs us. When we listen to it, we find it fascinating."

That night, walking home, I saw a garbage truck and heard its louder-than-usual accompaniment. Normally I would switch to another block. Instead, I decided to shoot. The truck was loading the noisiest possible trash: shards, scraps, and entire pieces of steel and aluminum ducts. The sound was earsplitting, but not just because of the decibel level. It actually felt dangerous in its texture and shape: hard, sharp, heavy. As I concentrated on the sound, the visual elements became more potent. It was not just visual, it was visceral.

A few days later, I experienced another everyday event in a new way. Like many people, I go to cafés to think, write, sketch, ponder a problem or a project. Being surrounded by a tapestry of sight and sound helps me to concentrate. But when my café-mates talk too loudly, especially on a cell phone, I get annoyed at their intrusion into my private space.

This time, instead of trying to ignore a cell phone conversation right next to me, I listened intently without looking at the caller. In fact, I copied down every word. The following is just a tiny piece of my transcript:

"She's really stressed, y'know. It's heart attackish. She should never have had that kid. Yeah. Well, she doesn't work, yeah. . . . So many clothes don't fit me. I didn't eat that whole pasta thing, by the way. I just had a few bites of it before I went to bed. Oh, I know, I was so starving I took some crackers. . . . So, last night when I got home, I had salsa which is no calories whatsoever, and I ate about ten spoons of salsa and no chips. . . . No, this isn't Saltines, they were the elongated square ones, you know. I found a recipe, remember I was telling you about, bean-based, ground beef, and a bunch of bacon, I forget, I don't even bake it. I baked it once and it came out dry. I can Xerox it for you. You put—I wanna say they're red beans. It really comes out good. Hello? Hello? Yeah, yeah, I heard it. . . . Y'know, I wanna go get fresh fruit, I can't keep eating out like this."

When I finally looked up from my notebook, I was surprised to see a slender, elegant young woman. As I took in every visual element—her earrings, hairstyle, shoes, cell phone—I realized that I was constructing a portrait of contemporary life. This twenty-minute episode was, for me, a cultural artifact, a small gem. I found it to be, as John Cage said, fascinating.

Does this mean that I will now consider all deafening city sounds as music, or inane cell phone conversations as creative fodder? I doubt it. But these exercises have given me another layer of seeing. I now have, as part of my creative library, one more color in my palette, one more shade in my tonal range, one more point in my sensory IQ.

7

THE TWENTY-FIRST CENTURY LANDSCAPE

You are on a video camera over twenty times a day. Are you dressed for it?
—Kenneth Cole store window, Fifty-seventh and Lexington, Manhattan

The
Invasion
of
Public
Privacy

There is a private space that each of us has when we are in public. It is a mental space between the conscious and unconscious, a state between vulnerable and secure. It exists only when you feel safe enough to let down your guard. It is a comfortable space that allows daydreaming, thinking, zoning out, and observing, whether you are in a museum or a laundromat, on the subway or a quiet street. Your private space allows you to think the thoughts you want to think. It is the right to be uniquely who you are, wherever you are. As an artist, I depend on this safe space. It allows me to be immersed in a physical and cerebral environment that feeds my creativity, where my ideas can grow without censorship, however intimate or ludicrous they may be.

For me, that vulnerability is what a democracy protects. But living in a democracy also means being part of a constant balancing act. One of the most basic conundrums in a democracy is the tug-of-war between the protection and the erosion of that right to privacy. We want our freedom of privacy, but we also want to feel safe. This conflict gets worse when it becomes difficult to decipher who among us is a threat. It could be anyone.

We live in the Era of Surveillance. Our tools for monitoring one another are ubiquitous and sophisticated. Google the phrase "video surveillance" and you'll find at least nine million ways of spying and being spied upon.

In a *Newsweek* Web exclusive, Jessica Bennett reported: "New York City. . . has a network of cameras that reaches far into the thousands, spanning subway stations, traffic signals, overhead awnings, and private businesses. The Metropolitan Transit Authority [plans] to add 1,000 smart cameras to the system's already 3,000-camera-strong surveillance system. . . . The New York City Police Department operates an additional 3,000 cameras. . . . Bill Brown, a kind of amateur surveillance-camera spotter, estimates the total number of cameras in New York City to exceed 15,000—a figure city officials say they have no way to verify because they lack a system of registry."

Because of 9/11, privacy and protection are in heightened conflict with one another. Think back to the McCarthy era, when we were faced with the Russian ("Commie") threat, and extreme measures were taken that resulted in the erosion of civil liberties. Everyone was a potential suspect, especially those in the arts, and anything from one's choice of clothing to one's choice of friends could result in their being called into court. The effect on the lives of writers, musicians, choreographers, and actors—Leonard Bernstein, Arthur Miller, Elia Kazan, Lillian Hellman, Jerome Robbins, and Paul Robeson are just a few of the most famous—was huge, whether they were the ones naming names or being named.

But the government is no longer the primary culprit when it comes to invasion of privacy. With the aid of ordinary and extraordinary technology, many people are conducting surveillance of their own, and their purpose is to find incidents or facts that will serve their personal goals. These efforts may be of value, such as successfully identifying a thief. They may be nefarious, like identifying a wealthy or weak victim to stalk and rob or kidnap. They may be subtle incursions, like collecting data for marketing purposes. Or the surveillance camera may be yours, protecting your family by watching the nanny while you're at work (where, by the way, your boss may be monitoring you).

A while back, as I was crossing the street at Fifty-seventh and Lexington in Manhattan, I saw a huge sign in the Kenneth Cole store window that said, "You are on a video camera over twenty times a day. Are you dressed for it?" Clever, I thought, enjoying their quasi-political ad campaign. Thanks to the invasion and reaches of reality television, you'd better look good—anytime, anywhere.

Later that day, I read an article in a travel magazine. It suggested that, while traveling, one should wear "nice" shoes. Doing so, the author wrote, would increase one's chances of being treated well. I thought again of the Kenneth Cole statement.

On the surface, "Are you dressed for it?" is asking, "Do you look good enough to be on TV?" But on a more insidious level, it is asking, "Do you look suspicious? Will you be singled out?"

If you do not want to be noticed while you are under video surveillance, then it's best to wear clothes that do not call attention. Do not stand out. Attempt to be a bit more invisible. And the best way to be invisible, like any chameleon will tell you, is to conform. Blend in; try to look like everyone else around you.

In her excellent essay titled "Private Lives, Public Spaces" in *Dissent* magazine, Molly Smithsimon writes, "Awareness that we are being watched by surveillance cameras can put us in a constant state of apprehension and self-consciousness whenever we are out in public. Sociologist Steven Flusty aptly calls this monitored public space 'jittery space.'"

After reading this chapter, I suggest you try this exercise: as you go about your daily routine, imagine that you are under constant watch by wildly different sources, like government officials, drug dealers, and corporate marketing firms. And remember that each of those entities may be saving, manipulating, sending, and selling your recorded movements and activities.

Then, be aware of any tendency to self-edit your activities, for fear of how they may be recorded for someone else's interpretation or manipulation. Are you protecting yourself by consciously (or unconsciously) altering your regular behavior? As an artist, you probably have a lot of experience in defending your unusual choices of lifestyle. How much harder would it be if you knew that those choices were being documented and collected without your knowledge, with the intention of being used against you?

And finally, think about what it would mean to lose that precious, private, vulnerable space, where your thoughts are free and roaming and curious and lazy and inspired. What would it be like to feel that you always had to wear nice shoes?

Private
Talk
in
Public
Places

A public performance by Geek Ink is described on the Web site *www.pedestrianproject.com* as follows: *"Pedestrian: A Walking Tour for Multiple Voices and Portable Phones* takes New York audiences on walking tours led by three actresses through the East Village. It allows the participants to 'eavesdrop' on cell phone conversations exploring the topic of loss—from lost tempers and lost loves to lost identities. 'Pedestrian' explores the public airing of private speech."

In the chapter "Why Do We Look at Art?" I refer to a gallery owner who said, "I want to be a part of my time; I want to know what was going on while I was here. The contemporary artist examines, for the rest of us, what's going on around us."

I believe that as artists, we are continually balancing our relationship to daily life. On one hand, we are immersed within everyday life as participants, and on the other hand, we are outside of it, consciously acting as observers. Our role is typically to translate that balance of personal experience and public observation into a tangible form, something that conveys an essence. First and foremost, that requires an awareness of, and attention to, the world that we occupy.

My own observations focus on how people live within their own private bubbles while they are in public spaces, and in particular how contemporary technology affects those private bubbles. The Pedestrian

Project prompted me to look further into the ways that cell phones affect the public/private dichotomy.

Often, when I'm obsessed with a particular issue, I ask friends, colleagues, students, and readers for their thoughts. When I asked these people how the cell phone has affected their lives, most of the answers were about *other* people's use of cell phones—especially in public places. After some reflection, I realized that the real issue being addressed was, as Pedestrian Project put it, "the public airing of private speech." Here are the responses, along with my observations.

The Use and Abuse of Public Space

How do we define public space? Do we own it collectively, or does each one of us have a separate piece? What are the unspoken rules, and how are they formed? Is public space aural as well as physical? With most respondents, the degree of anger was akin to road rage. We may not pay attention to public space, but as soon as it is violated, we get angry.

"Cell phone users could care less about the other humans that occupy their sphere. And that is just plain selfish."

"It's sooo annoying, as I have to hear dumb conversations if I am in a public space. More and more of these are about random, time-passing comments, like, 'What are you wearing?'"

"Their little public megaphone conversations revolve around such stupid things as 'the wonderful stuffed pork chop I had last night' or the pain they've been enduring from an infected hangnail."

The energy of most responses, however, was not so much about the shallowness of the conversations. Instead, the annoyance came from being forced to overhear them. Why is a cell phone conversation any different from the person-to-person conversation that takes place in, say, the very same restaurant or supermarket or city street?

Lack of Respect

Perhaps when you see only one half of the conversation, that person seems to be committing a greater breach of public space. The tone of a cell phone voice is distinctive. It is a little bit louder, and it is self-privileging. It implies a lack of civility. Over and over, people wrote about the cell phone

caller's sense of self-importance. What seems to bother people so much is the disregard for the caller's neighbors. Or more to the point, they seem to be saying, "I am annoyed at the disregard for *me*. I get mad because someone is ignoring me."

I thought about this recently when I watched a woman on a cell phone who was clearly trying to be as unobtrusive as possible. She even made apologetic eye contact with me. At that moment, I would have forgiven her anything and considered her a sister in this messy world, all because she simply acknowledged me as being important enough to communicate with.

The e-mails I received showed that cell phone users' lack of respect is even more insulting when it is aimed, albeit unknowingly, at a friend, relative, or colleague.

"How many times have you been out with someone you haven't seen in a awhile and they spend a chunk of the time on the cell while you and the rest try to patiently wait out the call so you can get back to that quality time you had set out to spend with them? How dare your callee spend uninterrupted time with us? How rude on both of their parts!"

Public space can be taken even further—into the home. Think of your kitchen as the family's public space. When one family member brings his own private matters into that place, he is, according to respondents, ignoring (and insulting) the rest of his family.

"Parents sometimes tend to take their work with them wherever they go. Work should be kept in their office and not in their pocket. The same thing happens with friends and family. When you're with someone, would you rather be talking to them or would you rather hear them talk to someone who's not even there?"

Be Here Now

I have often recited the title of Ram Dass's famous book, *Be Here Now*, as a sort of mantra, reminding myself to be "present." I'm especially concerned with my own lack of awareness as I walk and talk on my cell phone, oblivious to my surroundings. Many of the e-mails referred to this state.

"It seems to me that talking on a cell phone in almost any environ-ment is an exercise in not being present. "Rather than live in [or] for the moment, many cell phone users choose to exist in a conversational limbo—not really here, not really there."

But, as one e-mail chided,

"[People should] take control of the moment and relax. I go on long walks just fine with the phone held tightly in my hand but never once used. If I don't want to talk, I don't answer. Simple as that."

The conflict arises when this in-between world invades public space. The lack of awareness of one's immediate surroundings is benign when it's confined to a private place. But take it out in public and it enrages those who witness it. Often, an ugly argument ensues. As one young respondent wrote,

"Some people in stores talk on the phone in line at the cashier and when their turn comes up, they stay there talking and if someone gets in front of them, they start yelling at them."

Another e-mail put it more simply. *"I just don't like what they do to people."*

In his important book *The Experience of Place*, published in 1990, Tony Hiss introduced a concept he calls simultaneous perception: a "general kind of awareness of a great many things at once: sights, sounds, smells, and sensations of touch and balance, as well as thoughts and feelings. . . . Simultaneous perception helps us to experience our surroundings and reactions to them, not just our own thoughts and desires.

"Ordinarily, we seem to be completely separate from everything and everyone in our surroundings. . . . At moments when the boundaries flow together, perhaps even disappear, a different sense emerges. . . . Our sense of ourselves now has more to do with noticing how we are connected to the people and things around us—as part of a family, a crowd, a community, a species, the biosphere."

When we observe the ways in which we experience and participate

in physical space, it's important to increase our awareness of our shared environment, both as artists and as citizens. Our interactions in the most mundane of places—a train station, a public park, a neighborhood sidewalk—reflect how we share space in the world.

The Internal Retreat from Public Space

Between the years 1938 and 1941, Walker Evans surreptitiously photographed riders on the New York City subway. The resulting book is the re-released *Many Are Called*. In the foreword Luc Sante wrote, "The subway . . . is a neutral zone in which people are free to consider themselves invisible; time spent commuting is a hiatus from social interaction. Since the protocols of subway-riding advise turning your gaze inward, you can take off the face you wear for the benefit of others."

That inward gaze was a self-contained contradiction: it was a way of being alone together. It was a kind of communal separateness, a community of individuals respecting one another's private space.

After looking at the photographs in Evans's book, my own next subway ride was a study in human interaction (or lack thereof). I was curious: how has the "hiatus from social interaction" changed? Is this retreat into a personal zone the same as it was more than a half century ago?

The facial expressions I saw looked quite similar to those in the book, especially the inward gaze. Of course the clothes and accessories were different; in particular, the ubiquitous hat was replaced by two thin wires coming from each ear, joining in a V at the chest, then disappearing into a pocket or backpack.

But there was another, more subtle difference. When the train stopped and we all resumed our conscious place in public, the people with

the iPods were still in their private space. Sure, they were no longer in that daydream zone, but neither had they rejoined the public space. They retained their separation. When they reached the top of the stairs and regained cell phone coverage, they (and many others) speed-dialed and retreated further still.

Like the subway riders in 1938, we are still individuals who lose ourselves in thought in the most public of places. But as we add new and enhanced technology to our daily wear, the gaze has shifted to a more distant place.

Now, as I encounter the ubiquitous technology, carried as faithfully as a previous generation wore their hats, I wonder: How does our personal technology affect the ways we occupy, experience, and participate in the public sphere? Do we use personal technology as a form of retreat—intentional or not—from the physical, public space?

Rewind: The Sony Walkman

As we spin through our music libraries on our iPods, we should pay homage to their truly radical grandfather: the Sony Walkman. The Walkman was the mark of a new way that we, as individuals, occupy shared public space.

The Walkman was introduced in 1979, a time when boom boxes were growing in popularity. Boom boxes, for those of you who don't remember, were big, heavy, battery-powered, one-piece stereo sound systems with loudspeakers. Although the Walkman was not created in direct response to the boom box, it's instructive to make the comparison.

The boom box was intrusive—it was rude, loud, in-your-face, and antagonistic. But it was also inclusive—its sound was meant to be shared by anyone who wanted to listen. It could turn a city street into a neighborhood dance party.

The Walkman was the opposite. It was, in a sense, a polite gesture. It was small and unobtrusive. But it was also exclusionary. It spoke for its wearer, saying, "This is my personal space. Keep out." It was a retreat in two senses of the definition, i.e., noun and verb: a place to escape to, but also a backing away. One used it to shut out the world. It was a respite from aggression, a sort of passive-aggressive stance. "I am removing myself from you, but quietly." The Walkman (like the iPod today) directed the inward gaze to a distant, solitary space.

Fast Forward: The Cell Phone

The cell phone represents the next step in retreating from pubic space. The inward gaze has been redirected outward, toward a distant, *shared* space.

Unlike the Walkman (or iPod), the cell phone does not provide a solitary space.

On a cell phone call, we retreat from the current environment by removing ourselves from those within physical proximity and joining others elsewhere. We "travel" to some non-existent location: a simultaneously shared mental space.

In the chapter "Private Talk in Public Places," I include responses to the question, "How has the cell phone affected your lives?" Overall, the responses were angry comments about the self-centered nature of the cell phone users' intrusion into the public space. People wrote about the cell phone caller's sense of self-importance, and the disregard for his neighbors.

In this way, the cell phone is an aggressive retreat from the public space because it is both intrusive and exclusionary. The cell phone user's neighbors have to listen to a party that they have not been invited to attend.

Jump Ahead: aka Multimedia Phones

I looked again at Evans's book. This time, I was attracted to the photographs of subway riders whose gaze was not turned inward but was, instead, focused outward—in particular, to a newspaper. A number of the images were of people reading the paper, some of which showed the headline loud and clear, like the *Daily News*'s "PAL TELLS HOW GUNGIRL KILLED" (all caps of course).

Although these passengers were alone, they were not "in retreat." Instead, they were participating members of a shared public space. They connected to strangers through a common item: a newspaper headline about a current event that they were all aware of.

Like those subway riders of the late 1930s, you'll find that common focus in any subway car today: many people simultaneously reading the same sports pages, the same news headlines, the same words at the same time. Like their common inward gaze, they have found a communal separateness, alone together.

But today, you will also find a different, more solitary outward focus, an intensified retreat that comes from the concentration we aim at

our multimedia phones: feature-loaded devices that include Web browsing, e-mail, still camera, video camera, TV broadcasts, games, contact lists, calendar, music, podcasts, GPS, text messaging, and so on. Even deep in the subway, without a cell phone signal, there is more than enough to keep us entertained, productive, and removed.

As with a newspaper, one's focus is directed to an object in real physical space. However, like the Walkman and the iPod, it's a device that draws its user away from a shared community. While others on the train may be using the same gesture of thumbs hopping around on tiny keypads, there is no shared content.

With this personal technology, we occupy an efficient, comfortable, and entertaining private bubble. We are also more and more mentally removed. Our attendance in physical surroundings becomes more solitary, less shared. We are alone and separate in public.

You Lookin' at Me?

There's a woman I often see at the local Starbucks. The first thing I noticed about her was her sleek pocketbook and how well it went with her erect posture and long, straight hair. Once or twice she was with a man who I assumed was her partner or husband, because they were holding hands.

One night while watching TV, I was surprised to see this man in an advertisement. He announced his name, and since I was multitasking at my computer, I did the natural thing: I Googled him. Within seconds, I discovered that the woman was indeed his wife, and I learned her name and profession, and that they lived in Manhattan. My speed at obtaining this information was both thrilling and creepy. I stopped the search.

A few weeks later, I saw her on the street a block away from my apartment building. As she passed, I smiled at her as though she were an acquaintance. She looked puzzled—remember, this is New York and people don't tend to smile randomly at strangers—but she nodded back politely. Her hair was in tight curls, and I remember thinking, "I liked it better when it was straight."

Then it hit me: I had crossed the line from innocuous observer to borderline voyeur.

There is a sweet innocence to watching the world go by, sitting at a sidewalk café in a grand plaza, taking in the population's beauty, drama, and

diversity. The scenes are compelling and entertaining, without requiring real attention. You can watch individuals without being intrusive.

When does that change? What defines the line between harmless and threatening? It is when the anonymous becomes specific; when the accidental becomes intentional.

I was telling my crossing-the-line-search story, along with my concerns, to a woman I met recently at a party. After listening to her insightful questions, I was not surprised to learn that she was a professor of psychology. She responded to me by focusing on new technology and how it is making us all more voyeuristic. She summed it up this way: personal curiosity, plus the ease and omnipresence of technology, equals the seduction of pursuing more (and more and more).

I thought about my secret "relationship" with my neighbor. The simplicity with which I could find out more about her, especially in the privacy of my own home, was, indeed, seductive. But it was not only my curiosity that I was feeding, nor was it just the customary nature most of us have of immediately using a search engine for any question that pops into our minds. I was also tempted by the urge to meet a challenge. How talented am I at searching? Am I good at advanced searches? Hmmm, let's see if I can track this down, if I am clever enough, if I work the magic right and then, aha! I strike gold, there he is, and there's his wife's name, and then I find her Web site, and her picture, and so on—until I have clearly crossed the boundary.

There is a confluence of tendencies that compels us, not as ill-intentioned, cyber-stalking bad guys, but as good, smart people: the challenge of the search as you see your skills increasing, the feeling of being on a treasure hunt, all mixed with the very human emotions of empathy, curiosity, envy, and hope. I can't speak about the minds of stalkers or true voyeurs, but I can speak from the point of view of a typical urban dweller who shares both city and cyberspace with her fellow citizens.

For me, these treasure hunts are worth noting because they reveal something about who we are as participants in a contemporary culture. We are magnetically drawn to the easy, abundant, free activity of personal fact-finding, an increasingly habitual game at which we are becoming very skilled. Artists in particular are known for becoming so engrossed in their subjects that they exceed all sorts of limits. Technology allows—even encourages—boundary-crossing.

I'm not talking about our activities on Facebook or MySpace or other social networking sites, where people knowingly contribute to, or are at least aware of, the dissemination of personal stories. I'm talking about the vast amount of random private information about each of us that, when carefully pieced together, can paint a picture we never intended to present. And conversely, I'm talking about the voyeuristic painter in each of us, captivated by a hobby that we never intended to pursue.

What
We
Reveal

In the chapter "Sound Seeing," I write about the rewards of listening to city sounds, and how they can present a new perspective in seeing. I include a portion of a cell phone monologue that I overheard, and at the end, I say, "Does this mean that I will now consider inane cell phone conversations as creative fodder? I doubt it."

Wrong!

In fact, after writing that chapter, I began copying down snippets of the cell phone calls that I overheard on buses, in train stations, and in grocery stores. The more I listened, the more I heard how similar the conversations are—not only to each other, but to my own. Whether they were inane, trivial, or heavy, these archetypal exchanges were, in fact, creative fodder. In other words, when I really listened, they contributed to my perceptions about contemporary life, and the language inevitably found its way into my expressive work.

This should not have surprised me. For years, the subject of my artwork and much of my writing has been the way we share public urban spaces. Long before my focus on aural language, I was "eavesdropping" on visual imagery. My largest project is a series titled "Public Privacy: Wendy Richmond's Surreptitious Cell Phone." It consists of silent cell phone video grids of city life—people riding escalators, walking their dogs, watching a

parade, window-shopping—the steady and mundane urban choreography that we perform together.

I had no interest in capturing a dramatic or embarrassing moment; just the opposite. During the course of shooting over 1,600 videos, I found that the ones I wanted to work with were the "episodes" where nothing happened, but were full of the normal movements and gestures that happen every day: holding a coffee cup while maneuvering through a crowd, or rummaging through a purse while waiting for the subway. The overheard cell phone conversations that I began to pay attention to were the aural equivalent: recounting yesterday's errands, planning where to meet, worrying about a friend's illness.

During a television interview on NY1, the host Sam Roberts asked me, "Is New York City different from other places?" I responded that for me, a major difference was its extreme density and its inhabitants' intense, unconscious aptitude that enables us to share our public space. We are able to be close and simultaneously maintain our distance, maintaining a sort of privacy in public.

After the interview, I thought further. How are we able to handle this density, especially when the space we share is not only physical, but aural as well?

This prompted me to reconsider what I wrote in "The Internal Retreat from Public Space." In that chapter, I describe how city dwellers simultaneously occupy and retreat from public space: we create private bubbles—using personal technology like iPods, cell phones, and laptops—to serve as a buffer zone. But now, as I listen to these cell phone monologues (and reflect on my own), I realize that there is an inherent contradiction: the more we retreat, the more we reveal. By withdrawing into the bubble, that is, losing ourselves within our private, self-made spaces, we are simultaneously exposing more to the people around us. As we increase our use of personal technologies and all their features, we retreat further, and our bubbles become more robust. And therein lies the irony. The stronger the bubble, the more oblivious we are, and therefore, the more we reveal.

On a bus ride in the city the other day, I, along with the rest of the riders, heard a woman speaking loudly into her cell phone. "Don't worry, he'll be fine. It's like last time. He'll be fine." Then she made a few more calls, essentially repeating the same thing. "Lisa called me all in panic. I

told her not to worry. He's not, like, doubled over or anything." During these conversations, this woman was deeply ensconced in her privacy bubble, and yet an entire busload of people was in on the news.

In Jane Jacobs's classic book, *The Death and Life of Great American Cities*, she wrote, "Privacy is precious in cities. It is indispensable. Perhaps it is precious and indispensable everywhere, but most places, you cannot get it. In small settlements, everyone knows your affairs. In the city, everyone does not—only those you choose to tell will know much about you."

A lot has changed since Jacobs wrote these words. Have we abdicated our privacy by creating our ever more robust personal bubbles? Are we no longer choosing what to tell and to whom we will tell it?

Killing
Time

I was on a completely full plane, and we had already been sitting on the tarmac for ages when the pilot announced that it would be at least an hour before we would get off the ground. You can imagine the collective groan.

But then he said, "You can turn your cell phones on." The sudden burst of energy was like a bunch of kids just let out of school. The pilot had released us from that unbearable confinement: the prison of inactivity. In the following hour, I'll bet more than a hundred phone calls were sent and received. I listened to the calls closest to me, and it seemed as though most consisted of chatting with family members or friends.

This was a planeload of people who were simultaneously engaged in the exercise of killing time.

In our twenty-first century society, most of us have lives that consist of densely packed activities. We do so many different things in different locations with different people (even when we are just sitting at our computers) that we have created a byproduct: innumerable "in-between" spaces of time. They are the gaps that exist between finishing one thing and starting the next: the time between arriving at the doctor's office and being examined; between descending into the subway station and the train's arrival; between the barista asking, "What drink may I start for you?" and announcing, "Grande nonfat vanilla latté."

These gaps are typically short and unpredictable in length: empty moments that, for the most part, simply require us to wait.

But we never simply "wait," do we?

Because we are a hyperactive, hyperconsumptive society, we have to be busy, productive, and entertained, even during the in-betweens. Nature abhors a vacuum, and so empty spaces must be filled. To answer that need, we have created, and are consumers of, whole new industries for killing time.

There have always been industries that have catered to short bouts of waiting, even when the primary business is something else. Restaurants, bars, and cafés, for example, are for dining and hanging out. But the Starbucks on every corner is also a provider of a little something extra to do: sipping coffee, for instance, while you're waiting on a subway platform.

What interests me most is how many new ways there are to kill time, brought to us by new technology. The product requirements include speed, portability, and the ability to be interrupted at a moment's notice. They are mini devices for mini activities. Or, they need to be embedded in "smart" places where waiting occurs—airport terminals, bus stops, hotel lobbies—where you can kill time more effectively, enjoyably, and knowledgeably.

I travel a lot, and much of my waiting takes place at airports. Lately, I have been observing my time-killing habits more closely, taking care to notice how technology industries are providing products and services—intentionally or not—to fill the vacuum. My mini activities fall roughly into three categories: shopping, entertainment, and productivity.

Shopping

Let's start with the mother of all mini activities: shopping. The airline terminals are filled with shops and are becoming more and more like malls, with chain stores for jewelry, clothing, and souvenirs. Plus, there are stores to supply you with paraphernalia for your flight; along with books and magazines, you can buy batteries, DVDs, CDs, headphones, and other peripherals for your time-killing technology devices.

Or you can go to the Wi-Fi hotspots and continue to shop, this time using your computer. When I have miraculously passed quickly through security and have extra time (to kill), I peruse the books at the airport news stores and, disappointed, I go online to purchase and download a song or a podcast.

A crucial goal for a time-killing business is to sell more stuff more quickly. Whenever I go to Amazon.com, there are new, targeted suggestions for additional purchases. Filling out the forms is lightning fast because almost all of my contact and billing information is stored.

Last year I bought a bracelet at an airport store. The salesperson took forever to ring it up. I muttered to myself, "I could have done this faster online." But then I realized it didn't really matter. I never wear bracelets anyway, and I still haven't worn this one. I just bought it because I needed something to do.

Entertainment

Our cell phones are with us at all times, providing us with tons of features that serve as ideal time fillers, especially the video capability. The mobile phone is becoming the "fourth screen" in our everyday lives, the first three being the cinema screen, the television, and the computer. You can use your cell phone for video snacking. But do you really want to snack on more junk TV, even to kill a few minutes?

Productivity

Many people are desperate to be productive during waiting periods, and they accomplish a great deal with short spurts of e-mail, text messaging, Net surfing, and phone calls.

My most important device for productive mini activities is my heavy-duty set of headphones. You might put this in the entertainment category, for enhancing music-listening. But for me, it is a necessity for my most desperate need: to kill the time on the tarmac. That "in-between" is when I cannot use my laptop or cell phone (the above pilot-hero scenario is unusual) and when babies tend to scream. Couple that with the exasperation of not moving and having no idea when we will. Call me spoiled, but I find it hard to be productive under those circumstances, and a cocoon of clear, calm music helps me to think.

Inevitably, I come to the chicken-and-egg question. Which comes first: new technology or our need for it? In other words, is technology developed to address our need to kill time more effectively and enjoyably? Or do we have this desire because of our addiction to—and the effects of—new technology? A long time ago, when we were still allowed to bring

X-acto knives on airplanes, I made collages. Now, I busy myself going from one electronic device to another, like listening to my iPod while my laptop is booting up, or shooting pictures of the runway while we wait for take-off.

I wrote part of this chapter during a cross-country flight. I took a break to walk up and down the aisle to check out other people's killing-time technology—DVD players, iPods, computers, Game Boys, headphones . . . and then I came upon a young woman who was knitting. Knitting! After I passed her seat, I glanced back and saw a tiny DVD player on her tray table, screen glowing.

8

YOUR EXCITEMENT METER

When I try to do what someone else wants, I fail. But when I focus on what I want and how I want to do it, I succeed.
—Journal writing

Excitement
Meter

Artists are really interesting people. Compared to the majority of the population, artists are nonconformist, they are self-motivated, and they are innovative. Why then, when they consider career moves, do so many artists suddenly lose their inventiveness and look for a standard, narrow path that someone else has defined? I talk to a lot of people who are seeking advice about jobs, schools, or careers. They ask what potential employers, admissions officers, grant funders, or curators want. They seem to be looking for an existing model that spelled success for someone else at some other time.

As I have said before, when I try to figure out and then try to do what someone else wants, I fail. But when I focus on what I want and how I want to do it, I succeed. I have seen the same results in friends, employees, and students. Moreover, I've found that when people consider and honor all of their interests, however unrelated they seem, the juxtaposition leads to uniqueness and innovation.

So, when people ask me for advice, I don't talk about job openings or résumés. I talk about excitement meters.

I have an internal gauge, an indicator of what I find interesting and positive and worth pursuing. I call it my excitement meter. When I have a positive reaction to something, I take care to notice it. I don't try to come to any conclusions; I just register the reaction. At some later point, I look at this collection of seemingly unrelated ideas or events, and I usually find

a pattern that reveals something that I didn't see when I experienced each element in isolation. I do my best and most innovative work when I respect those patterns.

I believe that when you put together ideas or interests that you feel strongly about, but that seem to have nothing to do with one another, it is a recipe for innovation. The innovation comes from your observation of their juxtaposition. History is full of examples of innovations that have come from combining seemingly unrelated interests. It's especially interesting to read about early juxtapositions of technology and art. Georges Méliès, a stage magician who was a compatriot of the Lumière brothers at the turn of the century, was a magician who performed in the theater. His interest in the nascent medium of film, thrown together with his interest in the stage and fantasy, led him to discover many of film's unique characteristics. In his book *Development of Film, an Interpretive History*, Alan Casty writes: "Méliès used, mainly for magical effects, a kind of pseudo editing—juxtaposing disparate images by stopping and starting the camera. For example, in *A Trip to the Moon*, an umbrella becomes a mushroom. In *The Magical Box*, masking part of the camera lens gives the effect of the boy split in half. In numerous films, double exposures produce magical effects. Film language was definitely being spoken."

I also want to talk about a more personal kind of innovation. A juxtaposition of interests can lead to an innovation that is not material. It might be a new way of structuring a job, a career, a school, or a way of life.

Think of the people who have monitored their excitement meters closely and acted on their readings. I remember seeing an article in *Communication Arts* about John Plunkett and Barbara Kuhr, the designers of *Wired* and *Hot Wired*. They wanted to live and work in a beautiful location. They wanted to continue a successful design practice. And they were deeply involved in technology. Combining their interests in location, technology, and business (not to mention skiing), they moved to Park City, Utah, and worked remotely with *Wired* and other clients. Although they still needed face-to-face meetings and thus had to travel a lot, they still respected and acted upon the pattern that emerged from their interests. As a result, they developed a new model, an innovative way of living and working based on the elements that mattered the most to them.

It's easy to forget that innovation often has nothing to do with technology. I know a dancer whose passions include yoga, jazz, New York

City, and the ocean. Also, she suffered injuries early in her career and was determined to help herself and other dancers to heal and avoid further injury. Based on these combined interests, she not only invented a new form of jazz dance, she also started a studio in New York and a summer dance retreat by the ocean. She created innovations based on the things she loves—the peaks of her excitement meter.

Every now and then, the gauge on your meter may seem imprecise. An excitement meter requires attention; if you neglect it, you won't get clear readings. I've found that accuracy improves with age.

Visual
Episodes

One summer while traveling in Italy, I visited an archaeological site. It was a broiling hot day so I sought out shade in an underground passageway. The corridor was dark except where the sun came through holes in the ceiling and made a row of bright blobs on the ground. The shapes were stunning. My first thought was, "I want these." So, I took pictures, first of the row, then of each individual blob. I felt like I was at a flea market and had discovered a treasure—better yet a whole matched set—and I couldn't leave a single piece behind.

I enjoyed the experience. I decided that I would carry a small point-and-shoot camera with me on a regular basis. As a result, I became more aware of visual episodes: moments and spaces that, together, piqued my aesthetic interest. I started taking pictures to "see" more, to notice what I normally missed. The camera was an integral piece of this exercise.

My new habit made me curious about photography as a filter for seeing. In order to explore this activity that is so compelling to such a huge number of people, I decided to look for a book published back in 1970s: *On Photography* by Susan Sontag. It's still popular, and I found it easily in the bookstore. Within the first few pages there's a reference to photographing as a means of attaining ownership: "To collect photographs is to collect the world." Sontag goes on to explain, "Photographs really are experience captured, and the camera is the ideal arm of consciousness in its acquisitive mood."

I continued reading, discovering subtle variations. In addition to ownership, there is more that I'm seeking. I'm trying to develop a heightened awareness of my own aesthetic vision, as opposed to someone else's. Sontag's descriptions of the photographer-as-collector reminded me of my experience of seeing the shapes in the passageway. Not only did I want to have and keep those beautiful forms, I also felt that I had special claim to them. I was, I decided, a connoisseur of light blobs. Anyone else would have walked right by, missing the desirability of this dusty fortune. Sontag refers to the fact that the value of the object being photographed is unimportant, that the value lies instead in the photographer's vision.

This made me think about other visual episodes that attract my eye. I looked through a few sets of my slides and realized that they are primarily pictures of long, horizontal rows of short vertical elements. Like a collector, I seem to be acquiring a series. But in my case, the series is not of objects, it is of arrangements. My purpose is not to take great photographs; instead, I want to have the physical reminder of making a visual selection—one that I consider personally valuable—and enjoying it.

I found more examples throughout the book that helped me to articulate my reasons for taking photographs. For example, Sontag discusses the phenomenon of translating a recognizable object into an abstract form by photographing it close-up or by removing it from its normal context. Of the slides that I had shot in the underground passage, a few showed the entire corridor. Boring. But the shapes themselves—close-up, tightly cropped, and isolated from their surroundings—were mysterious.

However, just as isolation can make an object abstract and beautiful, the photograph can help you to see your own work from a new perspective. We all have ways to get a fresh look at something we've been working on and staring at for too long: taking a walk around the block, turning a piece of artwork upside down or looking at it in the mirror. I use photography to separate myself from my work. I remember a particular occasion when I created an installation in a gallery, concentrating only on the artwork itself. Later, when I looked at a photograph of the room, I was shocked to find that the work was competing with a patterned floor, an unnecessary ceiling light, and a badly painted door, all of which I had literally not seen.

After reading Sontag's book, I realize that the act of photographing is, for me, a way to explore and develop seeing. Taking pictures is like exercise, and the camera is the aid that helps me tone my aesthetic eyesight. It helps

me to see something I know too well, showing it to me from a new, unfamiliar perspective. It encourages me to isolate a visual event, and to translate it from a physical, named reality into something more abstract.

By carrying around a camera, I look harder. By taking a picture, I acknowledge and give credit to the shapes and compositions that please my eye, and I add to my personal collection of visual episodes.

In
Praise
of
Digression

It takes me forever to write a finished piece, whether it is an artist statement, an article for a magazine, or a chapter for this book. As I begin making notes about an initial idea, I'm reminded of something I saw or read or heard, and that starts the long and meandering process of going on all sorts of tangents. My curiosity diverts me to places both electronic and physical, from a quick plunge into Google to a spontaneous road trip.

I can't call this research because that would imply a purposeful pursuit of information. What I'm talking about is a conscious activity of wandering without a destination, allowing a space of time that is wholly unmapped.

I know this sounds indulgent and unrealistic. What about deadlines, bosses, clients, and hourly rates? And on top of that, we are trained to strive for efficiency and speed, taking the most direct route from A to B. My own tendencies to stray off track are always coupled with guilt. I tell myself to proceed in a logical fashion, to finish, to be "productive." But then I glance up at my bookshelves or my walls or my Internet bookmarks, and I see how much I have grown. If I allow myself to consciously engage in the process of wandering, I find that my work is bigger and richer and my knowledge base is deeper.

I want to encourage you (and remind myself) to allot mental space for this activity. Rather than berating ourselves for going off the path, can

we give ourselves some credit for our desire—and even our ability—to digress?

I've become familiar with my own patterns of digression. Perhaps you'll find similarities in your own working process. I recognize them as falling into two categories: left brain and right brain.

When I write in my favorite café, which has free wireless Internet access, my digressions are primarily left brain, fueled by Google, YouTube, and Amazon window-shopping (with an occasional purchase). The combination of caffeine and an infinite number of links has a powerfully stimulating effect on my analytical brain cells.

The chapter "Exhibiting the Complexity of Culture" is one recent example of circuitous routes. I started off by thinking about the ways that we, as U.S. citizens, represent and interpret other cultures. I remembered an essay in the *New Yorker* written by Susan Sontag just after 9/11. I found the article online, and, after rereading it, realized that it was not really germane to my topic.

Straying a bit further, I found an article about Sontag in the *Los Angeles Times* written just after her death. I was struck by this quote: "She remembered, as a girl of eight or nine, lying in bed, looking at her bookcase against the wall. 'It was like looking at my fifty friends. A book was like stepping through a mirror. I could go somewhere else. Each one was a door to a whole kingdom.'"

With a few more clicks, I learned that Sontag was responsible for bringing the work of cultural critic Roland Barthes, an author whom I have often quoted, to the United States. I also read that Gore Vidal once said that Sontag was more intelligent than she was talented. Somewhere along this journey, an advertisement popped up on the right side of my screen that invited me to take an IQ test. I skipped that path, but I did spend a few minutes making notes about how Google had essentially used Sontag for ad revenue.

In the end, I did not mention Sontag in that chapter at all. But I gained new knowledge that will influence future work, and hopefully these references will find their way into your left brain data bank as well.

When I am doing visual work, my digressions are typically right brain. For example, a few years ago, as I prepared my photographs for an upcoming book project, I took side journeys into Photoshop's "Help," and I rummaged through files of old images. A phone call interruption might cause

me to take a few minutes to review my latest camera phone videos. But my favorite meandering occurs in the physical space of my studio.

Like most artists, I have loads of visual artifacts that serve as sources of inspiration. To me, the best collections are constantly evolving; I like to think of them as evidence of ongoing digressions. I have allotted one wall in my studio to be specifically for digression. I tack, tape, or nail objects to the wall. There is no order, no theme. Instead, it is a place where I can collect items and pictures that simply interest me visually. The pieces come from trips across the country or across the street, and range from dried up leaves to postcards of Richard Serra's five-foot-tall etchings. When I look up from the depths of my work, I see surprising connections and patterns. This can elicit a revelation about my current projects, but more likely it will lead to a few minutes of looking out the window or a walk to a nearby gallery or bookstore. As with my writing, these references and diversions may not literally be included in my work, but each one will be part of my visual repertoire, a "door to a whole kingdom."

In the end, of course, one has to focus, commit, and strip away any digression. You, the reader, never see my actual process of digression. (But now you can imagine how many more pages were written before being distilled to this.)

The best work portrays only that which is essential. Every element is purposeful, and nothing distracts. This reminds me of a lesson about type design: every character must be subservient to the overall typeface, never jumping out or calling attention to itself, so that it does not divert the reader from the content. I can't quite remember where I read this comment but I'm sure I could find it.

But I digress . . .

Why
Do
We
Look
at
Art?

During several weekends in the fall, many cities across the country have open studios, events in which artists open their workspaces to the public. Open studios draw huge and diverse crowds, partly because of the food they offer (cookies and cider) and the fascination many of us have with exploring the spaces in which artists work. But the main reason that people come is to look at art.

Looking at art is a vital part of my life. When I travel to any city, the first places I look for are the art museums and galleries. At home, I try to see current shows. My idea of the perfect day trip is to visit a small town with a special exhibit.

After one of those open studio weekends, I began to think about this activity that I engage in, this looking at art, and I realized that I had never asked myself why. Why do I look at art? I was surprised to find that my answers were hard to articulate. I've asked a few friends the same question, and they have a similar reaction. It's something that seems obvious until you try to explain it.

I started to collect bits and pieces of reasons from random magazine articles, conversations, and my own rare moments of lucidity. And, as I often do when I'm trying to figure something out, I asked readers of my column in *Communication Arts* to write to me and tell me why they look at art. To get the ball rolling, I described two of my own reasons.

In the Holocaust Memorial Museum in Washington, D.C., there is a small area by the artist Ellsworth Kelly that is all white. The walls are white, and his artwork is white. For me, it was a place to contemplate what I had seen in the rest of the museum. It provided an almost invisible structure for me to fill with personal thoughts. When I find myself absorbed by an artwork, it is usually because I experience a balance; there is a specific objective as well as an invitation to personalize.

My second reason for why I look at art was articulated in an interview in *Stuff* magazine with Bernard Toale, the owner of a Boston gallery. The interviewer asked why he had opened his gallery. Toale said, "I want to be a part of my time; I want to know what was going on while I was here. The contemporary artist examines, for the rest of us, what's going on around us." When you look at the range of art from any era and geographic location, you learn a tremendous amount about what was, or is, going on. You learn about the concerns, values, and attitudes of a society in a time and place.

Soon after that column came out, I began to receive responses, and what a wonderful way to start the day! Picture this: every morning, as you sip your first cup of coffee, you check your e-mail. The first subject heading says: "Why I look at Art" and you get a message that goes like this: "When I see something I can really tune in to, it's like a rush, like some part of me is resonating to a layer of meaning that is just behind the art and is only suggested by the colors, forms, or strokes. Sometimes it's impossible to identify what about the work is so exciting. It's like being moved by music and having to dance."

For a month, that was basically how each morning began. Sometimes the responses were long—one was three pages—and sometimes very short: "Why I look at art: because of the way art looks at me."

I was not surprised to see that many readers look at art for inspiration. After all, the *Communication Arts* audience is made up of people who not only look at art, but create it, as well. What I did not expect was that many view art for the challenge. People said they view art in order to seek what they don't know, to grapple with the unexplainable. Some see art as an invitation to act despite fear of exposure. One woman was challenged by a quote from Jasper Johns, who "resolved to stop becoming an artist, and instead to be one." Almost every response expressed art-viewing as uplifting, an activity that urged or provoked creativity. As one person said, "I look at

art to see the result of creativity and imagination. I like to compare it to what I've done and what I believe I'm capable of doing."

Many responses stated that art reflects the age in which it was created, and tells us about history. "If you look carefully at art of different periods, you can almost place yourself in the frame of mind of the artist, in the context of his or her place in time." This resonated with the quote above from Bernie Toale.

However, the responses caused me to look at his statement again. The art that we see has been selected. What are we *not* seeing? What is not being represented? I recently attended an exhibit titled "Original Visions," a show of six women artists' work over the past three decades. The exhibition's catalogue discussed the problems of sexism in the arts: "Across the country, a large majority of the undergraduate art students are female, while most of their teachers are male. (In the early '70s, 2 percent of art faculty were female.) Women, compared to men, are exhibited far less frequently."

Think of all the situations in which social barriers prevent artists from being exhibited or even recognized. And there are innumerable cases of artists who are not seen because they are censored by their government. In our own country, we're in a climate of heated controversy about exhibitions and funding. Art, like all history, is edited, and we are getting a "curated" view of the past.

In the wonderful book *Between Artists: Twelve Contemporary American Artists Interview Twelve Contemporary American Artists*, Felix Gonzalez-Torres says, "Ask a few simple questions about aesthetics: Whose aesthetics? At what historical time? Under what circumstances? For what purposes? And who is deciding quality? Then you realize suddenly that aesthetic choices are politics."

I received many uplifting responses about childhood, people acknowledging their good fortune in having parents and teachers who presented art as a part of daily life (making it as well as looking at it). One respondent talked about going to the Museum of Modern Art every week as a child; at six years old, her favorite painter was Mondrian. Another spoke of the game he played with his mother, inventing tales for the characters depicted in paintings by Toulouse-Lautrec and El Greco.

These parents and teachers clearly encouraged children to appreciate, and perhaps participate in, the field of art. I think of my godchild, Sofie.

I buy her sketchbooks and markers and encourage her to draw. But why haven't I taken her to a museum? I plan to remedy that error soon.

The majority of responses showed people's desire to understand the unfamiliar. The more responses I read, the more I was inspired by people's sheer joy in trying to comprehend a conundrum. One woman wrote,

"I look at art to be fed mentally [and] emotionally. The feast of images can be positive, negative, or both because the heart of it is the fact that it affects me. It makes me think. It becomes another level where I am free to extract anything I want or need."

The following are more excerpts from the many e-mails I received.

"I am sometimes starved for creative thought, visuals, and opinions. Looking at art is an amazingly stimulating activity for me. I find myself thrown into new areas of thought and emotion, which prompts my mind to think creatively. I always come away from a gallery or other art viewing excited about life."

"Art captures a scene or concept at a particular point in time, freezing it there for us to see and experience anytime. At a time when life is moving around us at blinding speed, it is becoming harder to see the details of what you are looking at or even to think about what you have seen. Art provides us a way to slow down and take it in at our own pace. Looking at art is also a learning experience. How an artist has used shape, color, or space in a new way can spark creativity in my work. It is like having access to hundreds of teachers, anytime I want. Art is really about seeing, taking the time to look and reflect."

"I spend a great deal of time looking at art is because it is the only thing that lasts. People come and go from this world, but the art that lasts tells us the history of this world—where we have been and where we are going."

"Art of every age is a mirror of the culture that produced it, a timeless, universally accessible expression of human experience that allows me to take part. I also look at art just for the sheer enjoyment of form and color; my spirit soars from the experience."

"Art is not exactly a reflection of life. We give life understanding through art. Art, as such, is a study of our perceptions of reality, to a higher or lower degree."

"When I look at art, usually I am looking for inspiration, for some kind of originality. Some artists have a way of depicting ordinary characters and objects in unexpected ways. Something that challenges our fundamental way of looking at things brings us out of where we are and into another level. This is where the inspiration is fed."

"Art tells you about other people's worlds, and sometimes, if it is meaningful to you, it helps you experience yourself more completely. Art is what makes us human."

"I can see the world through someone else's mind. Like a good character in a novel, there's something present that rings true in my life, too."

"You asked why do I look at art, and I have to answer because of the blue. Let me backtrack. I once read in a novel called Earth, *by David Brin, a quote from a very wise unidentified person.* [Here is an excerpt from the quote.] *'Imagine an island of blue in the middle of a tropical storm, its eye of peace. You must admit the hurricane is there. To do otherwise is self-deception, which in nature is fatal, or worse, hypocritical. Even honest, decent folk must fight to survive when the howling winds blow. And yet, such folk will also do whatever they can to expand the blue. To increase that gentle, centered realm where patience prevails and no law is made by tooth or claw. You are never entirely helpless, nor ever entirely in it for yourself. You can always do something to expand the blue.' Without the blue, my world would be devoid of anything spiritual, peaceful, or even interesting. This is where we all make a stand against the harshness of a paradoxical world. Art allows me to dream, think and formulate art of my own. And by formulating art of my own, I expand the blue."*

Personal
Work

When I receive my *Communication Arts Illustration* and *Photography Annuals*, I go to the last section first, the one titled "Unpublished." Some of the work is unpublished because it was made for a proposal or it was an outtake from an assignment. Many pieces, however, were not made for clients at all.

As I look through the pages, I linger on the phrases describing those particular entries: "Personal project"; "Exploration of merging painterly effects"; "Portrait of Lisa, personal work"; "Paintings inspired by trips through the Mississippi Delta region"; "Between thoughts of faith"; and so on. The pieces are motivated by private exploration and inspiration.

Then, I look at the other sections, the successful pieces that have been commissioned and (hopefully) paid for, and I wonder how many years' worth of personal work had to be created first, before that illustrator or photographer could present a vision or personal style that was developed enough for the public (as in publication). It's hard enough to illustrate a client's editorial point or promote a product. But it's even tougher when the work involves one's own goals, deadlines, and money. And yet many "commercial artists" spend a huge amount of time making pieces that will never even be seen, let alone published. This activity may come from compulsion, intellectual exploration, a need for an outlet, pure joy, or all of the above.

This personal work provides indirect but vital development for the work that does reach a public audience.

For me, the most important aspect of personal work is the opportunity to have a private dialogue with my work. A friend agreed, describing her process of shedding the public editors of audience and client. "In the studio, the first thing I do is get out of my public clothes and into my painting clothes. . . . What matters to me is this conversation with my soul, this fluidity that nourishes all facets of my life, both public and private."

These conversations are unedited; they are places where one can explore and figure things out. I remember a conference in which Richard Saul Wurman eschewed a formal presentation in favor of a conversation between him and a colleague. His reasoning was this: when you talk to a group, you tend to repeat what you have said in the past, but when you speak with one other person, you are likely to express new thoughts. I would take this one step further: when you have a dialogue with your personal work you can say things—visually or verbally—that are not only new, but also risky. You can make mistakes. This is your R&D.

After all this thinking about the "Unpublished" sections in the annuals, I decided to ask the readers of my *Communication Arts* column, "How does your personal work feed your public work?" Most of the responses came, not surprisingly, from seasoned professionals. They described personal work as a foundation for public work—a process, even a ritual with which to achieve more powerful and meaningful work.

A response from a widely published illustrator reminded me that the deeper you probe personally, the broader your influence will be publicly. "Each illustrator develops a language. Personal work increases the vocabulary for that language. . . . It seems to me that the closer we get to our centers, the more alike we are. The basic needs and emotions that we experience can be represented by archetypes that we all relate to. For instance, an open door can represent the future, and how we draw that open door can determine how we feel about the future—is it foreboding or optimistic?"

Another respondent talked about gaining confidence and simultaneously allowing failure. That seesaw of confidence and doubt is ever-present in personal work. The challenge is to use it as a balance rather than a battle. In her book *Wet*, the artist Mira Schor says, "It is necessary to stand for something within yourself yet always doubt your own deepest beliefs." With persistent self-questioning, you shape your visual philosophy. By listening

to your doubts, you will continue to test. When you test, you will continue to prove. And when you prove, you will learn to trust your own instincts.

I am delighted when I hear that people who earn their living commercially are showing personal work in public. One response was from one of the judges of a recent photography show, who said that they all chose work that "either was, or was rooted in, personal work."

For me, the point is not whether personal work is better than commercial work. Instead, I want to acknowledge that it is hard for us to know that personal work is being done in the first place. We usually don't see or hear about this work, precisely because it is personal and was not created with the goal of showing it publicly.

Personal work is instructive and gratifying for those who create it and those who view it. I am grateful when I hear about professionals in visual communication who share something so important, especially when they share it with people who are in danger of leaving their own personal work behind.

Powerful work comes from empathy. As one e-mail concluded, "Dig down deep within yourself, and the personal becomes universal."

The Value of Time

In his book *A Giacometti Portrait*, James Lord describes his experience sitting for an eighteen-day period while Alberto Giacometti paints his portrait. He observes a repeating sequence: "Giacometti had begun to work with one of the fine brushes, using grayish and white paint, working on the head only. After a time, he began to use the large brush and white, painting the area around the head and shoulders and finally part of the face, too. This led me to infer that little by little he was painting out what he had previously done, undoing it, as he said. Presently he took one of the fine brushes and began to paint with black, concentrating on the head. He was constructing it all over again from nothing, and for the hundredth time at least."

When I read this passage, I considered it a metaphor for other creative processes. Whether we are involved in writing, designing, photographing, or drawing, we appreciate the value of time: time spent looking, deliberating, and repeating.

But do we really *practice* this appreciation? Or do we have an impatience, even an aversion to repetition or to allowing something to evolve? Books about time management give us examples of how to be productive: touch your mail only once, process it here and now, and never look at it again. We tend to give the most attention to whatever we have observed or constructed most recently. We forget what came before. We forget the

discourse that preceded the outcome. Because of this, we miss out; we don't consider the accumulated evidence of the passage of time.

There is a term in art history, *pentimento*, that refers to an underlying image in a painting, such as an earlier painting or an original draft that shows through. Pentimento conveys the artist's rethinking that comes out of the repeated line.

This term, as well as the passage about Giacometti's paintings, are often on my mind when I look at finished projects of colleagues and students, as well as my own. To me, pentimento is a reminder to observe the process, the evidence of learning and seeking; to look at the buildup, so to speak, that results from experience gained over time, whether that time is centuries, decades, or a few days.

I never write a column or article about anything that has not been germinating for at least two or three months. While a recent event may be an instigator, the subject is always something that has had time to rattle around in my brain. Otherwise, I simply don't trust that it deserves to be committed to print.

The piece of writing must also withstand many drafts. It begins with "freewriting," a stream of consciousness where I find the points that hold my interest. I save that and begin a new document, another stream of consciousness that is somewhat more focused. After a few of these, I begin to fill in the details. Inevitably, I come back with the broad brush and begin, like Giacometti, the process of "undoing": painting out the details, and looking again for the essential points. This process takes place over a number of days or weeks. The time between each draft is as necessary as the writing itself.

It's important to me that my students observe the evidence of the passage of time. Like most people, they are under a great deal of pressure and have very little time to reflect.

In one course, I asked my students to keep a daily journal and to observe, at a specified hour, the media that surrounded them. There were complaints: "Why do we have to do this every day? Isn't once a week sufficient? I don't have something new to say every day." The point of keeping a journal, however, is not to have something new to say every day. It is the exact opposite. The point is to find out what you have to say that is *not* new. When you consciously observe something repeatedly, on a daily basis, you find out what is lasting, what sustains, what you think about the most. You see which ideas receive your contemplation. You discover the essence.

A journal is a record, an accumulation of experience. When, after a few weeks, students looked back over their journals, they saw what lines repeated, as in the old masters' paintings. The ideas that mattered tended to stay; comments that were superficial pondering or false interests were fleeting, and appeared only once.

Creating a painting or writing drafts of an article or keeping a journal are just a few examples of tangible forms of process. They are activities that convey the value of repetition, careful observation, and the passage of time. They represent the accumulation of experience, the evidence of personal history: built up, painted over, and built up again.

Acknowledgements

Richard Coyne, founder of *Communication Arts* magazine, asked me to write an article in 1984, and I have been writing my regular column in the magazine ever since. His encouragement and trust have been carried on by the *Communication Arts* family, and I am especially grateful to Patrick and Jean Coyne and to my column editors Anne Telford and Rebecca Bedrossian.

My research, writing, and pondering reside in piles of notebooks, sketchbooks, hard drives, and scraps of paper. It is because of my readers, teachers, colleagues, and students that, for more than twenty-five years, I have translated these observations and reflections into articulated form.

I am grateful to Tad Crawford and the staff at Allworth Press for their encouragement and wise support, which enables me to offer an adaptation of my columns and writings into an extended, distilled, and hopefully comprehensive book.

I rely on the advice of many colleagues, who are enormously insightful and have fed the contents of this book. In particular, my gratitude goes to Muriel Cooper, Joseph Carroll, Michael Chladil, Angiola Churchill, D.K. Holland, Martha Mason, Carol McCusker, Ceasar McDowell, Maurizio Pellegrin, Fred Raab, and Paul Souza.

Most of all, I am indebted to my best friend, Susan Hodara. Without her "life support," this book—and its circuitous route—would not exist.

Bibliography

Cultivating Creativity

Bayles, David, and Ted Orland. *Art & Fear: Observations on the Perils (and Rewards) of Artmaking*. Eugene, Ore.: The Image Continuum Press, 1993.

Developing a Creative Practice

Rieff, David, ed. *Reborn: Journals and Notebooks, 1947–1963 Susan Sontag*. New York: Farrar, Straus and Giroux, 2008.

Amulya, Joy. "Passionate Curiosity: A study of research process experience in doctoral researchers." Doctoral diss., Harvard Graduate School of Education, 1998.

Frames and Filters

Barthes, Roland. *The Rustle of Language*. Berkeley, Calif.: University of California Press, 1989.

Pilgrimage

Kimmelman, Michael. "No Substitute for the Real Thing." *New York Times*, February 22, 1998.

Identity and Authenticity

"Informal Economy Vendors." Exhibition featuring the work of Julio Cesar Morales at the Museum of Contemporary Art San Diego (MCASD) in San Diego, Calif.: 2004.

Rodriguez, Richard. "A Cultural Identity," interview by Jim Lehrer, *The NewsHour with Jim Lehrer*, PBS, 1997.

Exhibiting the Complexity of Culture

"Between Past and Future: New Photography and Video from China." Exhibition at the International Center of Photography and the Asia Society and Museum in New York, NY: 2004.

"Past in Reverse: Contemporary Art of East Asia." Exhibition at the San Diego Museum of Art in San Diego, Calif.: 2005.

Constructed Walls

Rachel Whiteread. Interview by John Tusa. BBC Radio. Transcript, www.bbc.co.uk/radio3/johntusainterview/whiteread_transcript.shtml.

First, Accept No Harm

Wechsler, Lawrence. *Seeing Is Forgetting the Name of the Thing One Sees: A Life of Contemporary Artist Robert Irwin.* Berkeley, Calif.: University of California Press, 1982.

Designing the Self-Critique

Hockney, David. *Portrait of an Artist: Hockney the Photographer.* VHS. Chicago, Ill.: Home Vision, 1983.

Components of Collaboration

Daniels, Barry, ed. *Joseph Chaikin & Sam Shepard: Letters and Texts, 1972- 1984.* New York: New American Library, 1989.

MacFarquhar, Larissa. "The Better Boss: How Marshall Goldsmith Reforms Executives." *New Yorker,* April 22, 2002.

Your Portrait or Mine?

Conover, Ted. "Truth and Betrayal in the Editing Room." *New York Times Magazine,* March 30, 1997.

Thiebaud, Wayne. *Vision and Revision.* San Francisco, Calif.: Chronicle Books, 1991.

Your Cell Phone, Your Self

Winner, Langdon. *Autonomous Technology.* Cambridge, Mass.: The MIT Press, 1977.

The Quality of Technique

Stieglitz, Alfred. "The Hand Camera—Its Present Importance." *The American Annual of Photography,* 1897.

Rexer, Lyle. "Chuck Close Rediscovers the Art in an Old Method." *New York Times,* March 12, 2000.

Memory Is Cheap

Thompson, Clive. "A Head for Detail." *Fast Company,* November 2006.

Concentrating on Form

"Powers of Ten." *The Films of Charles & Ray Eames,* Vol. 1. Directed by Ray Eames (1968; Chatsworth, Calif.: Image Entertainment, DVD, 2005).

Benjamin, Walter. "The Work of Art in the Age of Mechanical Reproduction." 1936.

Learning (Again) from Las Vegas

Venturi, Robert, Denise Scott Brown, and Steven Izenour. *Learning from Las Vegas*. Cambridge, Mass.: The MIT Press, 1972.

Another Kind of Language

"Drawing Is Another Kind of Language." Exhibition at the Sackler Museum in Cambridge, Mass.: 1998.

"Yo-Yo Ma Inspired by Bach." Public Broadcasting Service. Oley, Pa.: Bullfrog Films, 1978.

The Power of Language

Cohn, Carol. "Sex and Death in the Rational World of Defense Intellectuals." *Signs: The Journal of Women in Culture and Society* 12, no. 4 (1987).

Promoting Visual Thinking

John-Steiner, Vera. *Notebooks of the Mind: Explorations of Thinking*. New York: Oxford University Press, 1997.

Why Do You Draw?

Leebron, Fred G. "Not Knowing." *The Eleventh Draft*, ed. Frank Conroy. New York: HarperCollins, 1999.

Csikszentmihalyi, Mihaly. *Flow: The Psychology of Optimal Experience*. New York: Harper Perennial, 1991.

Beyond Description

"Ann Hamilton: Kaph." Exhibition at the Contemporary Arts Museum in Houston, Texas: 1997. *Kaph* catalogue can be found at the museum's Web site at www.camh.org/exhib_mus_pubs_gh.html.

Fisher, Thomas. "Design Feature: Image Building, Architectural Photography." *Progressive Architecture*, August 1990.

"Case Study House #22 1635 Woods Drive—Above Sunset/Laurel Canyon, Los Angeles, CA." The Architectural Photography of Julius Shulman, www.usc.edu/dept/architecture/shulman/image_collection/CSH22.html

Drohojowska-Philp, Hunter. "VANISHING." *Artnet*, November 2005.

Maya Lin: A Strong Clear Vision. Directed and written by Frieda Lee Mock (2003; New York: New Video Group, DVD, 2003).

Thurber, Jon. "Ezra Stoller, 89; Made Classic Photos of Buildings by Leading Architects." *Los Angeles Times* (November 4, 2004).

Sound Seeing

Cage, John. "The Future of Music: Credo." First delivered as a lecture in 1937.

The Invasion of Public Privacy

Bennett, Jessica. "Big Brother's Big Business." *Newsweek*, March 2006.

Smithsimon, Molly. "Private Lives, Public Spaces." *Dissent*, Winter 2003.

Private Talk in Public Places

Hiss, Tony. *The Experience of Place*. New York: Alfred A. Knopf, 1990.

The Internal Retreat from Public Space

Evans, Walker. *Many Are Called*. New Haven, Conn.: Yale University Press, in association with the Metropolitan Museum of Art, 2004.

Excitement Meter

Casty, Alan. *Development of Film, an Interpretive History*. San Francisco, Calif.: Harcourt Brace Jovanovich, 1973.

Visual Episodes

Sontag, Susan. *On Photography*. New York: Farrar, Straus and Giroux, 1977.

Why Do We Look at Art?

"Original Visions: Shifting the Paradigm, Women's Art 1970–1996." Catalogue for exhibit at McMullen Museum of Art. Boston, Mass.: Boston College, 1997.

Between Artists: Twelve Contemporary American Artists Interview Twelve Contemporary American Artists. Los Angeles, Calif.: A.R.T. Press. Dist. New York: Distributed Art Publishers, 1996.

Personal Work

Schor, Mira. *Wet: On Painting, Feminism, and Art Culture*. Durham, N.C.: Duke University Press, 1997.

The Value of Time

Lord, James. *A Giacometti Portrait*. New York: Museum of Modern Art, 1965.

Index

Books from Allworth Press

Allworth Press is an imprint of Allworth Communications, Inc. Selected titles are listed below.

Learning by Heart: Teachings to Free the Creative Spirit
by Corita Kent and Jan Steward (6⅞ × 9, 232 pages, paperback, $24.95)

The Artist's Guide to Public Art: How to Find and Win Commissions
by Lynn Basa (6 × 9, 256 pages, paperback, $19.95)

The Business of Being an Artist, Third Edition
by Daniel Grant (6 × 9, 354 pages, paperback, $19.95)

Selling Art without Galleries: Toward Making a Living from Your Art
by Daniel Grant (6 × 9, 256 pages, paperback, $19.95)

The Artist-Gallery Partnership: A Practical Guide to Consigning Art, Third Edition
by Tad Crawford and Susan Melton (6 × 9, 216 pages, paperback, $19.95)

Fine Art Publicity: The Complete Guide for Galleries and Artists, Second Edition
by Susan Abbott (6 × 9, 192 pages, paperback, $19.95)

Legal Guide for the Visual Artist, Fourth Edition
by Tad Crawford (8½ × 11, 272 pages, paperback, $19.95)

Business and Legal Forms for Fine Artists, Revised Edition
by Tad Crawford (8½ × 11, 144 pages, paperback, includes CD-ROM, $19.95)

Guide to Getting Arts Grants
by Ellen Liberatori (6 × 9, 272 pages, paperback, $19.95)

The Artist's Complete Health and Safety Guide, Third Edition
by Monona Rossol (6 × 9, 416 pages, paperback, $24.95)

Artists Communities: A Directory of Residences that Offer Time and Space for Creativity
by the Alliance of Artists Communities (6 × 9, 336 pages, paperback, $24.95)

Caring for Your Art: A Guide for Artists, Collectors, Galleries

and Art Institutions, Third Edition
by Jill Snyder (6 × 9, 256 pages, paperback, $19.95)

The Fine Artist's Guide to Marketing and Self-Promotion, Revised Edition
by Julius Vitali (6 × 9, 256 pages, paperback, $19.95)

To request a free catalog or order books by credit card, call 1-800-491-2808. To see our complete catalog on the World Wide Web, or to order online for a 20 percent discount, you can find us at *www.allworth.com*.